MAX HITS
BUILDING AND PROMOTING SUCCESSFUL WEBSITES

RotoVision

MAX HITS

BUILDING AND PROMOTING SUCCESSFUL WEBSITES

MIKE SLOCOMBE

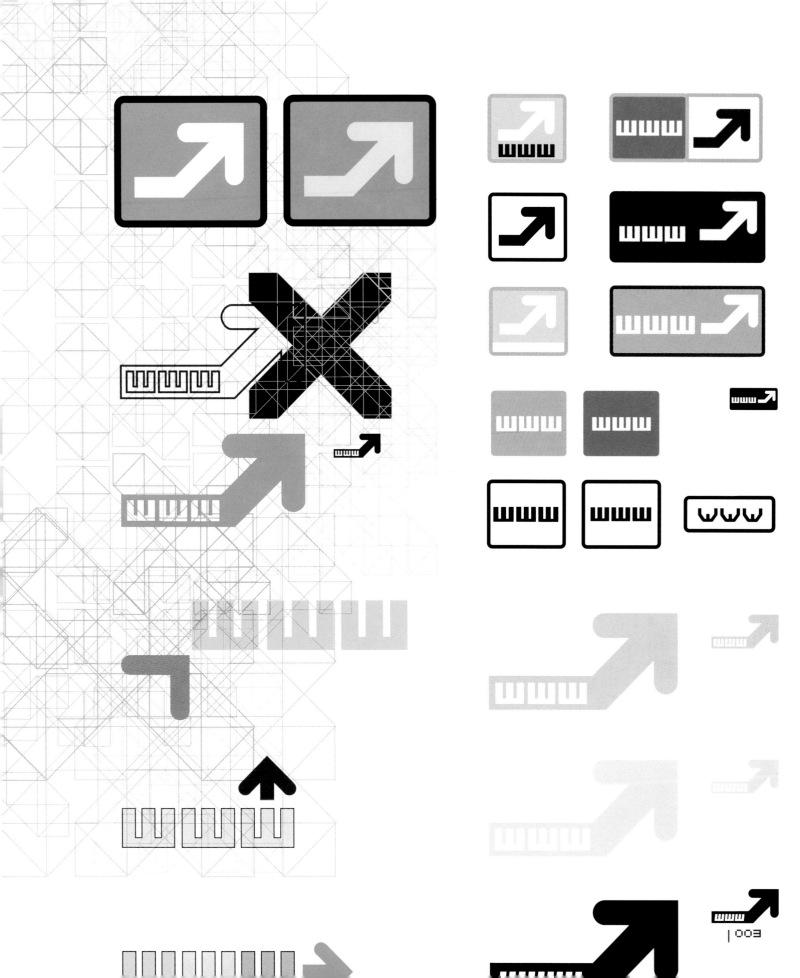

Published and distributed by RotoVision SA

Sales, Production & Editorial Office
Sheridan House, 112–116A Western Road
Hove, East Sussex, BN3 1DD, UK

Tel: +44 (0)1273 72 72 68
Fax: +44 (0)1273 72 72 69
Email: sales@rotovision.com
Website: www.rotovision.com

ISBN 2------88046---------543---5

10 9 8 7 6 5 4 3 2 1

Design by **bark** email: bark@barkdesign.demon.co.uk
www.barkdesign.demon.co.uk

Separations by ProVision Pte. Ltd., Singapore
Tel: +65 334 7720
Fax: +65 334 7721

Printed and bound in Hong Kong by Printing Express

00 >
CONTENTS

OVERVIEW

WITH OVER EIGHT-BILLION WEB PAGES EXPECTED TO BE ONLINE BY 2002, GETTING YOUR WEBSITE HEARD ABOVE THE NOISE MAY SEEM AN IMPOSSIBLE TASK.

AS NEW TECHNOLOGIES MAKE THE PROCESS OF CREATING YOUR OWN SITE SEEM EVER MORE COMPLEX, YOU CAN'T BLAME SOME PEOPLE FOR THINKING THAT WITHOUT A TROUSER-BULGING BUDGET AND A ROOM FULL OF MARKETING AND TECHNICAL STAFF, THEIR SITE IS DOOMED TO OBSCURITY.

FORTUNATELY, IT'S NOT ALWAYS THE MOST EXPENSIVE OR COMPLICATED WEBSITES THAT SUCCEED, AND THIS BOOK WILL ILLUSTRATE HOW GREAT WEBSITES CAN BE PUT TOGETHER REGARDLESS OF BUDGET.

>>

Placing ideas, inspiration and originality at the forefront, this book aims to demystify the process of website creation and to help you make a site that will keep your visitors coming back for more.

Using real-world examples, case studies and tutorials, the book investigates the key factors needed to build a successful site, following the path all the way from inspiration to completion.

Software and computer platforms are compared; key issues such as style vs. content and design vs. function are discussed, along with tips on how to get your site noticed, using offline and online marketing.

Several key industry figures are interviewed for their opinions and advice with the focus firmly on ideas, not on tedious technical mumbo-jumbo.

Tapping into the energy and inspiration that has made some of the best sites on the web, this book aims to be an invaluable resource for anyone building or commissioning websites, teaching the value of good design, research and planning.

A successful site can be within anyone's grasp. Go for it!

MAX HITS

www.wireframe.com
p 70

www.preloaded.com
p 61

www.antidot.com
p 16

www.mobilesdisco.com
p 142

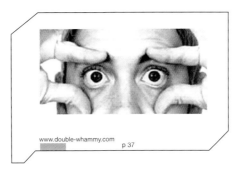
www.double-whammy.com
p 37

www.bongo11.com
p 52

www.sissyfight.com
p 151

www.retroscope.com
p 14

www.radiohead.com
p 13

www.deepend.com
p 55

www.evanhecox.com
p 130

www.tate.org.uk.
p 136

www.artistica.org p 50

www.kraftwerk.de p 116

www.beardedlady.com p 71

www.petercook.net p 147

www.assembler.org p 110

www.copyrightdavis.com p 59

www.scooterdeath.com p 40

www.famewhore.com p 109

www.marktucker.com p 134

www.goldtop.org p 13

www.bongo11.com p 52

www.presstube.com p 29

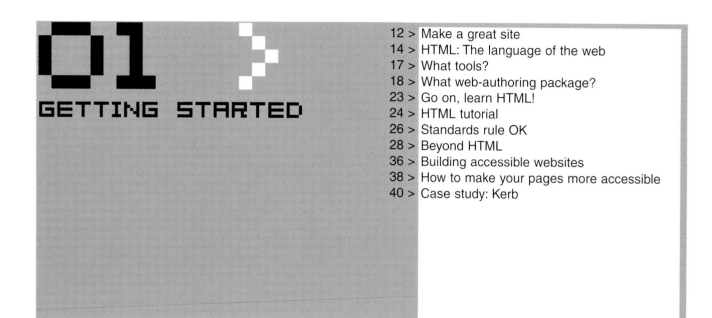

01

GETTING STARTED

MAKE A GREAT SITE

One person's definition of a great site is quite likely to be different from another's. For some, a site's not worth visiting unless it's stuffed full of the latest multimedia widgets, while to terminally obsessed football fans like myself, even the most slapdash site documenting the trials and tribulations of a struggling, lower-league football team is an essential bookmark.

And therein lies the crux of the web: it's not always the most lavish sites that succeed, and originality and individualism can often triumph over big corporate budgets and expensive, gizmo-laden spectaculars.

Giving the people what they want is the key to a successful website and the subsequent chapters will help you identify your audience and build a site to deliver the information they want in a manner that is appropriate to the content.

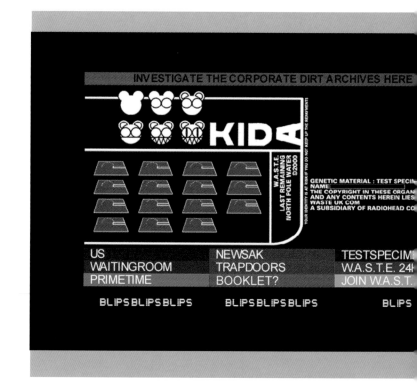

PACKAGING
COWS
SWEETS
 ⊛ 1 - 5
 6 - 10
 11 - 15
SCIENCE
TEETH
FLASH
MISC.

Some milk related sweet packaging from various shops.
The Smith's milk chews and milk'n'honees come from
our trips to NY, the fudge au lait was a 4p sweet from
Selfridges I found whilst supposedly Christmas shopping,
and the little tooth from some Japanese milk chews. I can't
work out whether your teeth get happy from you eating
these sweets or what!

MILK | WEB STUFF | DRAWINGS | PRINT | DIAGRAMS | PHOTOS CONTACT

You might ask, 'why this milk thing?', and to tell you the truth
I'm not sure - it kind of crept up on me. I just love the imagery,
the packaging, the whole idea that milk is this cool, fresh, 'every
thing you could possibly want' from a drink thing. And then, pow!,
I ended up with this collection of stuff that just keeps growing!...
★ updated 7th october 2000

★ packaging pour in gently | cute cartons
 cows
 sweets
★ misc. milky book
 science
 teeth
 flash

milk

MILK | WEB STUFF | DRAWINGS | PRINT | DIAGRAMS | PHOTOS | HOME

PACKAGING
COWS
SWEETS
SCIENCE
TEETH
FLASH
MISC.
 ⊛ BOOK
 FLASH

mmm... das schmeckt!

these are pages taken
from some books I have
made all about milk.

The front and back
covers were made
of Japanese milk
sweet wrappers...

milk is good for

strong bones

it's no use
crying over
spilt milk.

oops!

by the time I'd eaten
enough sweets to make
all the covers, I felt
quite sick!

You can be sure that no matter how obscure
the subject, there'll almost certainly be
some people out there who'll enjoy it.
Emerald Mosley, author of the popular
www.goldtop.org explains, 'what began as a
collection of mostly printed ephemera and
milk-related graphics grew into a website
that now has people sending me examples
from all over the world.'

www.goldtop.org

REPRODUCTIVE CAPACITY OF CLONES
THE DIAGRAM BELOW SHOWS REPRODUCTIVE FAILURE,
UNCERTAIN EFFICIENCY OF CELL MODIFICATION,
POSSIBILITY OF BREEDING OF LARGE NUMBERS OF OFFICE
WORKERS FROM A SINGLE FEMALE 'QUEEN',
& UNTESTED SURVIVAL RATES IN CONJUNCTION.

BACKGROUND AND LEGAL FRAMEWORK
RESOURCE AND CORPORATE POLICY IMPLICATIONS
FUTURE PRIORITIES
CONSULTATION THEN LYING CONSISTENTLY
HUMAN GENOME SEQUENCING STATUS
NUCLEAR TRANSFER STATUS
CLONING MISCARRIAGE STATUS

Radiohead's quirky and highly political
website is an inspiring example of how
musicians can use the web to open up new
lines of communication with fans.

www.radiohead.com

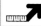

HTML: THE LANGUAGE OF THE WEB

HTML (HyperText Markup Language) hasn't always been the graphic-rich medium you see on your screen. It started life as a way for boffin types to share scientific information, with the focus being on delivering content, not on producing interactive, multimedia extravaganzas.

Although HTML documents may make look complex at first, they're nothing more than simple text files that almost any computer can read – hence their universality. What makes HTML so special is its support of hypertext or links. These can take the form of underlined text, graphic buttons or 'hotspots' which can link one web page to another or call up sound files, video clips, Flash movies etc.

Although almost any computer can display web pages, what those pages will actually look like depends on a host of factors including the computer, the monitor, the speed of the internet connection and what software is used to view the page (called the browser, e.g. Netscape or Internet Explorer. Until fairly recently, most people would only ever view websites through a computer but now there are all kinds of gadgets that can access the web, from tiny phones to home TV sets.

Faced with such a profusion of displays, web authors have to face the serious question about what compromises they're prepared to make – or invest – in multiple versions of the same site, optimised for different displays. And it's not just the hardware that's changing the face of the web. With new authoring languages like XML, XHTML and Flash creating fresh challenges, should web authors go for the latest whiz-bang multimedia presentation tools or keep it simple for users on older browsers and WAP phones?

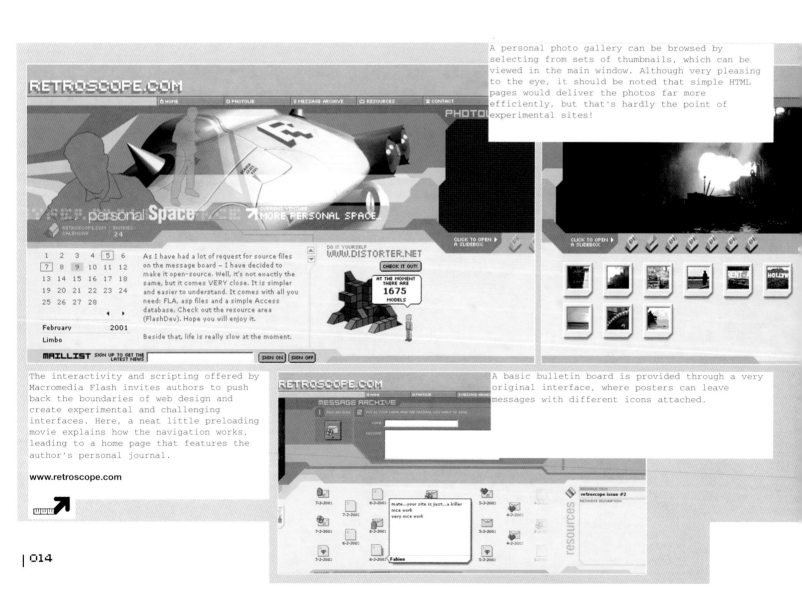

A personal photo gallery can be browsed by selecting from sets of thumbnails, which can be viewed in the main window. Although very pleasing to the eye, it should be noted that simple HTML pages would deliver the photos far more efficiently, but that's hardly the point of experimental sites!

The interactivity and scripting offered by Macromedia Flash invites authors to push back the boundaries of web design and create experimental and challenging interfaces. Here, a neat little preloading movie explains how the navigation works, leading to a home page that features the author's personal journal.

www.retroscope.com

A basic bulletin board is provided through a very original interface, where posters can leave messages with different icons attached.

HOW IT WORKS:
NET VS. WEB

The internet is the all-embracing term that covers the public global network of computers able to exchange data in different ways. The internet lets you do all kinds of useful things with people from all over the world – like send email, fight invading aliens in online games and start pointless arguments in newsgroups.

The web is a subset of the internet and websites are accessed using web browsers like Netscape, Internet Explorer, Opera etc. Web pages are generally written in HTML and can include text, graphics and multimedia files. A website is nothing more than a pile of files sat on a machine that is permanently connected to the internet. These machines are known as web servers and they let anyone else connected to the internet transfer files off the server to their own machine – which is basically what happens when you look at a web page.

When you visit a website your browser says, 'Hey server! Gimme the text and pictures for this page!' to which the server replies (if it's friendly), 'Sure dude! Help yourself!' The files are then transferred from the server to your machine and your browser lays out and displays the document according to the HTML instructions in the page. These web page files are temporarily saved on your machine in what's known as a cache. This speeds up the display of pages you frequently visit or have already seen, because your browser can open them from your computer instead of from the web.

It doesn't matter where web servers are physically located – so it's not unusual to find that a website about New York might have the files actually stored on a web server somewhere thousands of miles away.

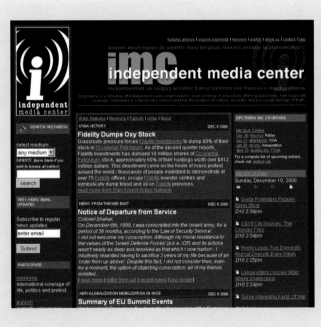

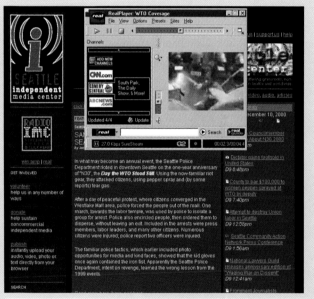

As globalisation becomes a major political issue, the internet is proving to be the perfect tool for reporting on the issues and coordinating truly global protest. Campaign groups like www.indymedia.org create mobile news centres at the heart of major protests, using local journalists and reporters to stream action live over the Internet, offering alternative viewpoints to media heavyweights like CNN and the BBC.

www.indymedia.org

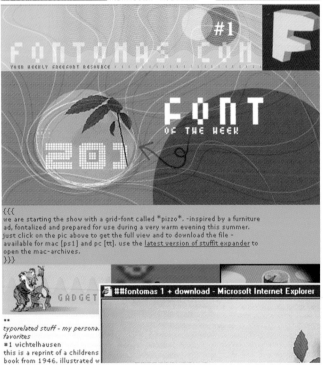

WHAT TOOLS?

Let's get one thing straight: you create the website – not the software, or the computer. Expensive software suites may simplify the process but you definitely don't need them to build your site, neither do you need any particular operating system – just about anything will do.

Occasionally you may find yourself being bored to death by someone insisting that their operating system is miles better than yours. Ignore them. Tell them to go away.

The reality is that apart from a few minority specialist applications, it makes no difference whatsoever which machine or operating system you use. The same or similar web-authoring software is available on both [PC] and [MAC] platforms with capable alternatives available on less familiar platforms like Unix and Amiga. Simply go with whatever system you find yourself most comfortable with.

One final note: don't be fooled by all the adverts insisting that you'll need the latest ten squillion megahertz machine stuffed with tons of RAM to author a website. Just so long as your ancient steam-powered PC has a modem, a browser and it can run a basic paint package and text editor, you'll be fine.

Dirk Uhlenbrock is a commercial designer based in Brussels, Belgium. He set up www.fontomas.com in 1998 after deciding to give away ten self-designed fonts. He then added the non-commercial www.antidot.de website two years later.

Like many designers working in a corporate environment, Dirk feels it's important to keep working on personal material, 'When you work on corporate stuff you only get filtered information about the users' reactions. This is my direct connection to real life. I like to do free and non-profit stuff for pleasure and to keep my brain fresh and healthy!'

www.antidot.com

WHAT WEB-AUTHORING PACKAGE?

WYSIWYG: WHAT YOU SEE IS WHAT YOU (SOMETIMES) GET

Example programs: Microsoft Frontpage (PC), Macromedia Dreamweaver (MAC+PC) Adobe GoLive (MAC+PC), NetObjects Fusion (MAC+PC), Amamya (Linux)

WYSIWYG programs look like the perfect answer. Why bother with all that horrible coding stuff when you can just drag and drop graphics around the screen and make pages like you do in Quark or Word? Sadly, all this simplicity comes at a price that some experienced web developers find a little too high. WYSIWYG programs are notorious for serving up rather over-generous portions of unnecessary HTML code which authors often have to cut out in a text editor afterwards.

Also, since it's often easy to create a 'professional'-looking site with the supplied templates, these same graphics may end up being used on hundreds of other sites – not what you want if you're trying to make your website stand out.

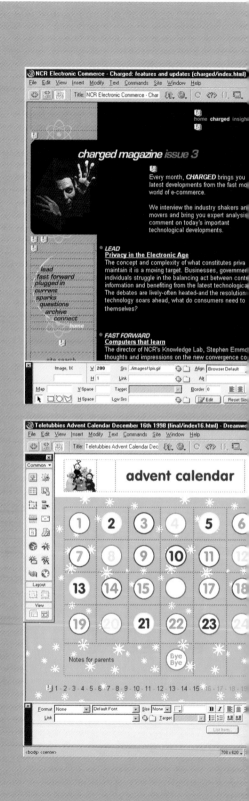

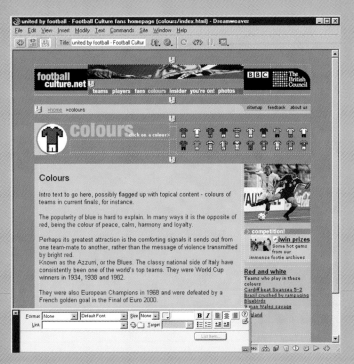

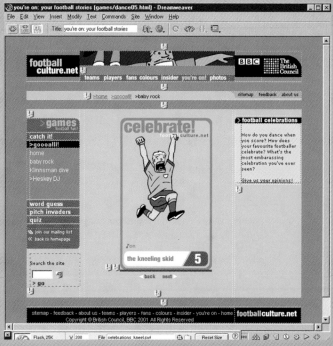

Many professional authors have settled for the compromise of using WYSIWYG editors like Dreamweaver for building quick mock-ups of a page and then exporting the files to a text editor for tweaking and stripping down the code. This working practice has become more common as technologies like DHTML produce complex pages that can make authoring strictly by hand an onerous task. Even so, most experienced authors can't resist the temptation to use their knowledge of HTML to fiddle with the page to make it quicker to download. But be warned – it's easy to get a little obsessive and find the hours rolling by as you desperately try to squeeze that last byte out of your page.

WYSIWIG programs

HTML TEXT EDITORS

Example programs: Homesite [PC], HotDog [PC], CoffeeCup, [PC] [Linux], Arachnophilia [PC], 1st Page [PC], BBEdit [MAC], Emacs [ALL PLATFORMS]

Building sites with a text editor may seem an arduous and fiddly business at first, but with a good understanding of HTML, you can control your pages more precisely and have a far better chance of fixing things when they go wrong. Most HTML text editors come with a huge range of specialised tools and shortcuts to simplify and speed up the authoring process, and with many offering instant previews via an integrated browser, it needn't be a time-consuming affair.

Some of you may be tempted by the much trumpeted 'export to HTML' options available in word-processing packages like Microsoft Word. Although it's probably the fastest way to convert a text document to HTML, the results are often excessively slow to download. Use the right tools for the job and break out the HTML editor!

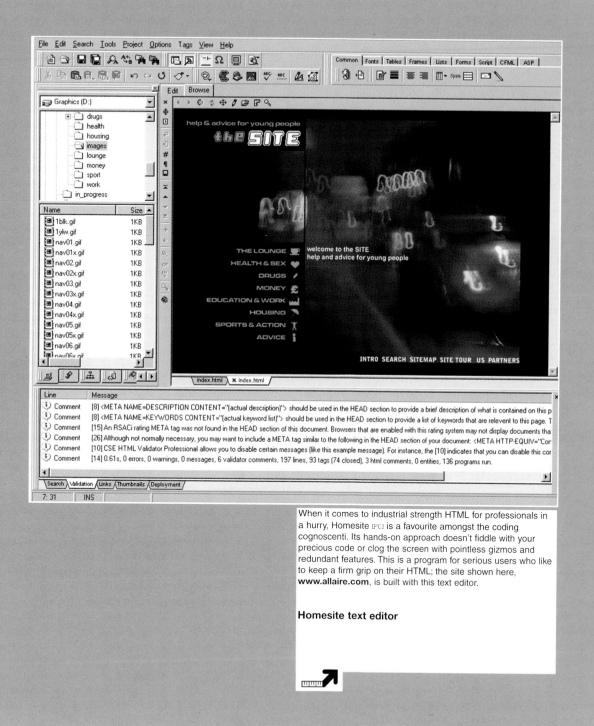

When it comes to industrial strength HTML for professionals in a hurry, Homesite [PC] is a favourite amongst the coding cognoscenti. Its hands-on approach doesn't fiddle with your precious code or clog the screen with pointless gizmos and redundant features. This is a program for serious users who like to keep a firm grip on their HTML; the site shown here, **www.allaire.com**, is built with this text editor.

Homesite text editor

ASP, DHTML, CSS

www.presstube.com

www.presstube.com

FOOTBALL — FA CUP SEC
CARDIFF CITY 3-1 CHEL
The Bluebirds battled
the third round after
fight by the visitors

Cheltenham were far m
the opening period an
lead after five minut

minutes when a Kevin

www.cardiffcity.com

www.assembler.org

GO ON, LEARN HTML!

The prospect of building a site with a WYSIWYG editor and being shielded from all that nasty, fiddly code may seem initially appealing, but many authors quickly get frustrated by their restrictions.

The greatest benefit of learning HTML code is that it encourages experimentation and individuality, putting you in control of your work. Importantly, a good knowledge of HTML will enhance your work prospects if you fancy a job in the web business and prove useful if you're interested in moving on to JavaScript and other scripting languages. While it's easy to get totally intimidated by the baffling technologies like ASP, DHTML, CSS and ActiveX that surround the web, it's worth noting that many sites rely on nothing more than simple HTML for their core content. It really is a simple thing to learn. Honest!

One of the best ways of learning HTML is by peeking at the code of sites that are already online. You can do this by selecting:

'view -> source' in Internet Explorer or
'view -> page source' in Netscape

Although you may initially shriek in horror at the sight of a naked web page, it doesn't take long to develop a working understanding of the language.

HTML TUTORIAL

This short tutorial will help you create your first web page. You won't need anything more than the basic text editor that comes with your machine – Notepad [PC] or SimpleText [MAC]. To make things easier, I've missed out some technical stuff that you don't really need to know right now.

HTML uses a set of instructions called 'tags' that signify the meaning of the text (it doesn't matter if they're written in uppercase or lowercase, but it's best to try and be consistent).

Most of these tags are fairly logical and easy to remember; **<P>**means paragraph**</P>**, ****means bold****, **<I>**means italic**</I>** and so on.

Notice that we have **** and ****. This is how we open and close HTML tags, so **** means 'start being bold' and **** means 'stop being bold'.

To display topic headings, there's a series of tags ranging from **<H1>** to **<H6>**, with **<H1>** representing the most important and **<H6>** the least important. **<H1>** is normally displayed in a large text size, **<H2>** slightly smaller etc.

Let's give it a go. Type everything below exactly into your text editor.

```
<HTML>
<HEAD>
<TITLE>My first web page</TITLE>
</HEAD>
<BODY BGCOLOR="YELLOW" TEXT="BLACK">
<H1>Important heading goes here</H1>
Whatever you type here will appear in the <B>browser
window</B>.
<H2>Lesser heading here</H2>
More text here.
<P>
Here's a new paragraph with <I>italic text</I> followed by a
link to <A HREF="page2.html">another page</A>.
</P>
</BODY>
</HTML>
```

Save the page as 'index.html', double-click on the file and that's it: one web page!

You'll notice that we made a link to another page called, **page2.html**, so we'll have to make this page first before the link will work.

The quickest way is just to copy the entire contents of this first page we created into a new text file and rename it – you've guessed it! – **page2.html**. Now we need it to link it back to the index page so change the link near the bottom of the page to: ****back****.

Make sure you save the file into the same directory, then reload **index.html** into your browser, click on the underlined link and you should be enjoying your first set of connected pages!

Now, flushed with success, why not try experimenting a bit? Change the colours in the **<BODY BGCOLOR="WHITE" TEXT="BLACK">** tag and see what happens. And, once you've convinced yourself that maybe it isn't that hard after all, why not start checking out some of the resources listed in this book and get building your own site?

After all, there's no better way to improve your HTML skills than sticking a website online and learning by your mistakes.

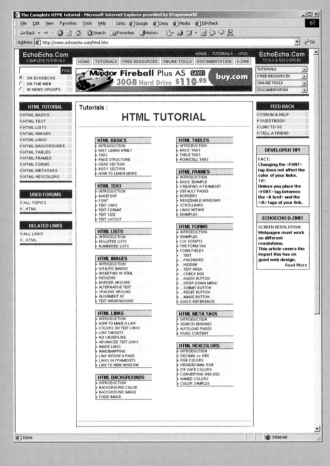

A web page is nothing more than a plain text file, saved as an HTML file so that a browser knows what to do with it. Follow this tutorial up by using one of the many on the web.

My first web page

www.echoecho.com

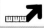

STANDARDS RULE OK

The internet works best when everyone understands each other, and with this in mind, the World Wide Web Consortium (➔ **www.w3.org**) was set up to persuade the web community of the benefits of universality, suggesting compliance to agreed standards that would work in all browsers.

Early HTML standards offered only the minimum of basic text formatting tools and it wasn't until the introduction of HTML 3.2, that things started to look up for designers, with the **<TABLE>** tag getting designers particularly excited. Info:
➔ **http://htmlgoodies.earthweb.com/tutors/table.html**

As new features are added to the HTML specification, some older browsers are unable to display the intended content, leaving designers to ponder whether they should force users to download the latest browser or author to an older HTML standard to guarantee maximum compliance.

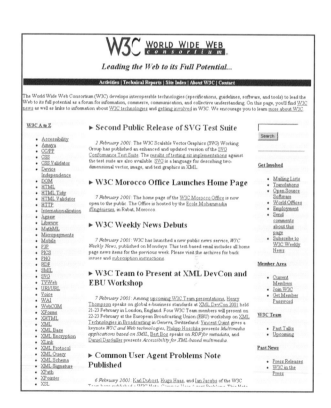

The current standard, HTML 4.01, offers considerable layout control, although it remains bedevilled with browser incompatibilities, rendering some of the more interesting features virtually unusable. Cascading Style Sheets also offer great potential for web authors, although cross-browser support can be iffy. (Note: the W3C has recommended a move to XHTML, but don't worry – HTML will be around for a long time yet!)

NON-STANDARD:

A major headache for web designers is the long-raging battle with the annoying incompatibilities between the big two browsers (Netscape [MAC] /IE [PC]).

Problems started back in 1994 when Netscape decided to forget all about universality and serve up a feast of appetising new features that would be guaranteed to send authors rushing to use their software. Suddenly, designers could add loads of new tricks like coloured, different-sized text and background images, with the ability to view multiple pages on screen. While this was great news for those who wanted to run Netscape, surfers not using the program would most likely get a page full of errors and sometimes no page at all – but Netscape wasn't bothered because by June 1996, it had become the most popular computer program in the world. Around this time Microsoft finally woke up to the possibilities of the internet and soon started adding its own non-standard features that would only work in their own browsers.

And so it has continued to today, with software companies continuing to extol the virtues of their own, proprietary web applications, making the task of authoring websites needlessly difficult (the Web Standards Project calculated that designers waste 25 per cent of their time devising workarounds for proprietary tags).

See: Web standards FAQ:
www.webstandards.org/edu_faq.html

HTML tables let web authors build complex layouts, using various tricks to position elements across the screen. Individual graphics can be sliced and optimised in graphics programs like Photoshop and then reassembled in HTML using table cells. Using **<TABLE BORDER="0">** the grid of the table becomes invisible, and combined with ROWSPAN and COLSPAN attributes, just about any grid-based layout can be reproduced.

As a last resort, designers sometimes have to use the 'single pixel trick' to guarantee absolute positioning: **www.killersites.com/1-design/single_pixel.html**. This involves stretching a transparent 1 x 1 pixel GIF to force graphic elements around a page. Although generally effective, it's better to try and get the same effect using the **VSPACE** and **HSPACE** arguments in the **** tag.

When you're working on complex grids like this, it's always best to sketch out the table first using pen and paper(!) and experiment with different layouts.

Although style sheets offer more precise positioning control than tables, inconsistent browser support and the issue of backward-compatibility means that layouts using tables have the best chance of working across multiple browsers.

HTML tables

The Worldwide Web Consortium home page

BEYOND HTML

The limitations of HTML have resulted in other technologies like JavaScript, CSS, Java, Flash and CGI scripting being developed to deliver text, graphics, audio/video and user interaction in (sometimes) more interesting ways. Here are the main ones:

CSS (CASCADING STYLE SHEETS)

Style sheets are groups of style rules – groups of properties that define how an HTML element appears in a web browser, e.g. Arial, italic and blue. Styles can be defined either within an HTML document or in an external file that can be linked to multiple pages (or even a whole site) making side-wide changes easy to implement.

Although style sheets use a different syntax to HTML, they're not particularly complicated to learn and designers will soon appreciate the extra control over page layout and text formatting offered, with the bonus of simplified coding and increased accessibility. They can also be used with JavaScript to create dynamic and powerful DHTML effects – check out ↗ http://htmlguru.com for some stunning examples.

There are a few downsides to using style sheets: not all browsers currently fully support CSS and some will render pages quite differently depending on the browser (see here: ↗ http://css.nu/pointers/bugs.html)

The good news is that browsers that don't understand style sheets will still display the content.

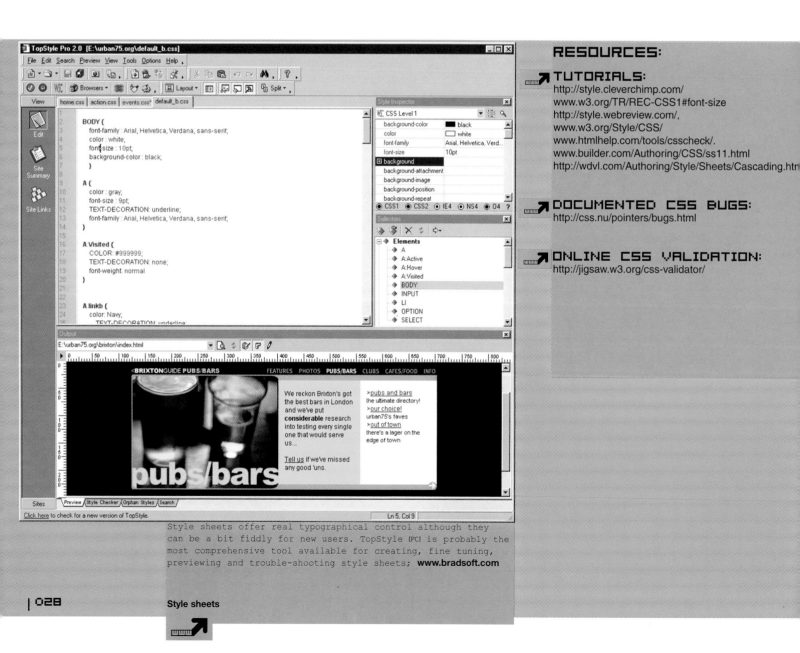

Style sheets offer real typographical control although they can be a bit fiddly for new users. TopStyle [PC] is probably the most comprehensive tool available for creating, fine tuning, previewing and trouble-shooting style sheets; www.bradsoft.com

RESOURCES:

TUTORIALS:
http://style.cleverchimp.com/
www.w3.org/TR/REC-CSS1#font-size
http://style.webreview.com/,
www.w3.org/Style/CSS/
www.htmlhelp.com/tools/csscheck/.
www.builder.com/Authoring/CSS/ss11.html
http://wdvl.com/Authoring/Style/Sheets/Cascading.htm

DOCUMENTED CSS BUGS:
http://css.nu/pointers/bugs.html

ONLINE CSS VALIDATION:
http://jigsaw.w3.org/css-validator/

Style sheets

XML:

Extensible Markup Language is similar to HTML in that it uses tags with added parameters to describe content. The big difference is that whereas HTML only has predefined functions, XML lets you define whatever new tags you want according to your needs; for example: a heavy drinker's site may use <beer> and <whisky> tags. By using style sheets, XML completely separates content from formatting, providing extra information which can be gratefully scooped up by search engines and data-processing applications. XML is a far stricter language than HTML, demanding case-sensitive input and precise coding.

If all this is making your head hurt, relax: it's doubtful that XML will replace HTML in the short-term future, but it will most likely be used as a flexible container for languages and protocols like Java, Active X, JavaScript, DHTML etc. Find out more about XML at:

➚ **www.xml.com** and ➚ **www.w3c.org/xml**

XHTML

Just when you thought you were getting the hang of this HTML thing, the W3C has announced that it intends to release no further enhancements to HTML, instead approving a recommendation for version 1.0 of Extensible HTML or XHTML.

This is a stricter, cleaner version of HTML that attempts to meet the demands of a wider range of devices accessing the same web content. It looks like an XML-ised form of HTML with start and end tags but stricter rules: all XHTML documents are lowercase and all tags, including empty elements, must be closed. This language is intolerant of sloppy coding and insists on a strict separation between content or structure and presentation by using style sheets. Find out more at: ➚ **www.w3.org/TR/xhtml1/**

high bandwidth animation tunnel
heaving portion

sketchbookutor
sketchbookutor

architecture of engagment
ART+DRUGS+PRINCE
species-a
species-b

mypen
chainwave-1
chainwave-2
ribbon

zoom nav

presstube

James wrote a chapter for a book called "New Masters of Flash." The chapter explains the building of "sketchbookutor" step by step, and has FLAS that accompany the whole process.
you can go and check the book out at the Friends Of Ed website.

www.friendsofed.com

It has chapters from 18 other Flash artists and designers, and looks like it is going to be a mofo phonebook. yeah. so go and buy it.

www.amazon.com

Sites don't get much more weird and wonderful than this mad offering!

Cutting-edge Flash animation and dance beats combine with a highly unorthodox interface that not only demands some patience to find your way round the site, but a high-powered machine too!

www.presstube.com

JAVASCRIPT

Scripting comes in several flavours, with JavaScript being the most popular (Microsoft's clone version is called Jscript and their own similar, but less popular, language is called VBScript). It's a great starting point for designers looking to understand programming, with a huge amount of useful resources and downloadable examples available on the web. Scripts can be used to add interactivity to your site and perform useful functions like checking that forms have been filled in properly, making pop-up alerts and adding bits of HTML code on the fly (like printing the time on a page).

Useful navigation tools like drop-down menus and graphic 'rollover' buttons (where an image changes as the mouse goes over it) can be created. You can even write scripts to make games.

James wrote a chapter for a book called "New Masters of Flash." The chapter explains the building of "SketchBookUtol" step by step, and has FLAs that accompany the whole process.
You can go and check the book out at the Friends of Ed website.

www.friendsofed.com

It has chapters from 18 other Flash artists and designers, and looks like it is going to be a mofo phonebook. Yeah. So go and buy it.

www.amazon.com

MUSIC!!!
90% of the beats on this site are engineered by the almighty K-Rad. buy their shit.
Radk-Rad

presstube related sites
thejamespatersonarchive
halfempty

conact
email James P
email Robbie Cameron
email Eric Jensen

links

0003
wireframe
praystation
extralucky
uncontrol
kioi
differentlevel
dextro
turux
re-move
designskinky
modern living
jamstatic
evil-pupil
thesquareroot

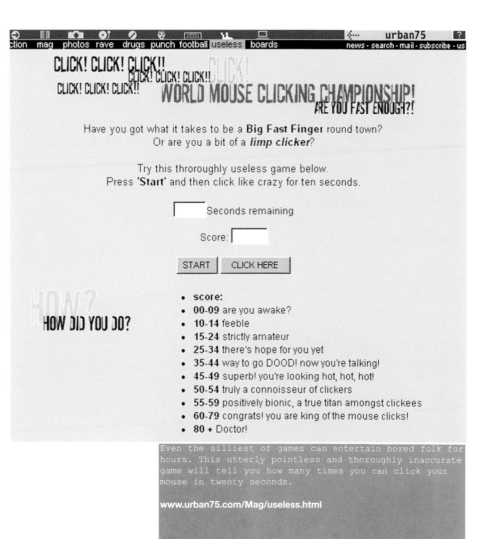

CLICK! CLICK! CLICK!!
CLICK! CLICK! CLICK!! CLICK!
CLICK! CLICK! CLICK!! **WORLD MOUSE CLICKING CHAMPIONSHIP!**
ARE YOU FAST ENOUGH?!

Have you got what it takes to be a **Big Fast Finger** round town?
Or are you a bit of a *limp clicker*?

Try this throroughly useless game below.
Press '**Start**' and then click like crazy for ten seconds.

[] Seconds remaining

Score: []

[START] [CLICK HERE]

HOW DID YOU DO?

- score:
- **00-09** are you awake?
- **10-14** feeble
- **15-24** strictly amateur
- **25-34** there's hope for you yet
- **35-44** way to go DOOD! now you're talking!
- **45-49** superb! you're looking hot, hot, hot!
- **50-54** truly a connoisseur of clickers
- **55-59** positively bionic, a true titan amongst clickees
- **60-79** congrats! you are king of the mouse clicks!
- **80 +** Doctor!

Even the silliest of games can entertain bored folk for hours. This utterly pointless and thoroughly inaccurate game will tell you how many times you can click your mouse in twenty seconds.

www.urban75.com/Mag/useless.html

Using advanced JavaScript (also known as Dynamic HTML or DHTML), HTML elements can be moved around a page, be exactly positioned, react and change to a user's interaction and dynamically hide and show content as needed.

As ever, there are a few caveats: not all browsers support JavaScript (some people turn it off in their browser preferences) and coding errors can render some pages unusable. Never use JavaScript for 'mission critical' navigation on a site without offering a non-JavaScript alternative – and most of all, be sure to test it in a variety of browsers and operating systems before unleashing it on an unsuspecting public.

CGI

CGI stands for Common Gateway Interface and it's a standardised way of sending information between the server and the script. Perl is the most common language used for CGI scripts, others are C++, Visual Basic and AppleScript. They are used to create a host of traffic-generating features like guest books, bulletin boards, chat areas, online games, search engines and database connectivity. There are a host of resources on the web where you can pick up free scripts to use and adapt, although you may find the coding more than a tad daunting at first.

To get you started, take a look at 'cgi tutorials for the total non-programmer' **http://webteacher.com/cgi/** and check out the free scripts at Matt's Script Archive **www.worldwidemart.com/scripts/** and **www.cgi-resources.com/**

Because running CGI scripts on servers can cause some security problems, most free/home page ISPs won't let you run your own corrections, but instead offer a range of basic free scripts like form submissions and counters instead. To run your own CGI scripts, expect to invest in some commercial web space.

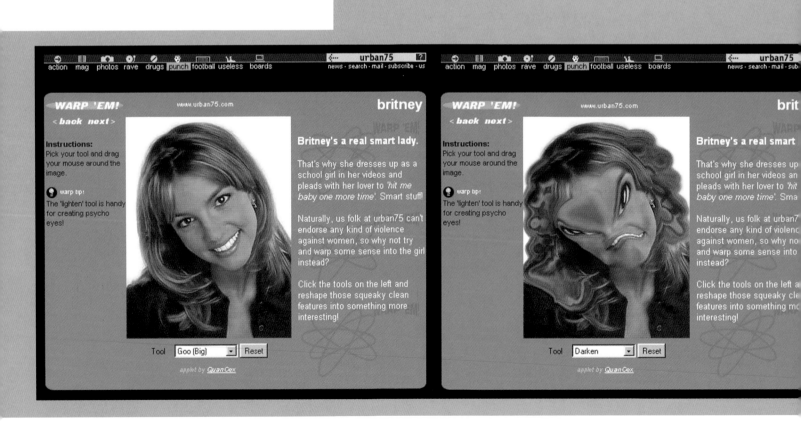

JAVA

Not to be confused with JavaScript, Java is an object-oriented programming language designed by Sun Microsystems. Java applets are platform–independent little applications (hence the term 'applets') that can be embedded on your pages to add special effects and interactive events. Although some applets can be mighty impressive, be warned that not all browsers support Java and some applets can slow down pages considerably, or even crash machines.

If you wish to use Java on your site, I'd definitely recommend that you avoid using it on your home page. Many office environments have Java disabled for security reasons and it can make your site less accessible to others, so consider using Flash or DHTML instead.

There are loads of downloadable applets for you to explore and slap on your own site at: **www.gamelan.com**, and you can find out more about the language at: **http://java.sun.com**

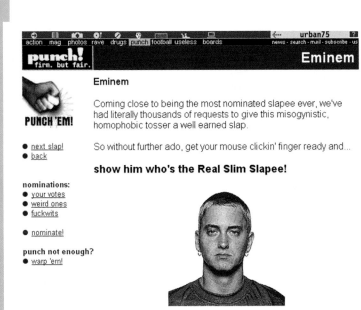

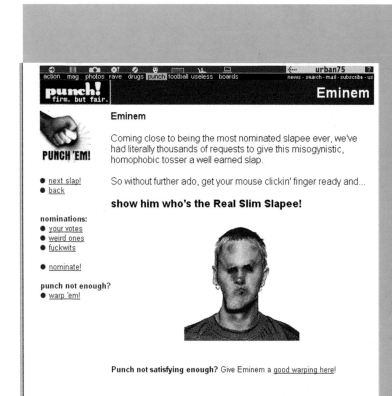

Java can add some fun interaction to a site. The 'Punch' gallery at **www.urban75.com/Punch/** has received millions of visitors keen to give the likes of George W Bush, Eminem, Tony Blair and Bill Gates a 'well-earned slap'. The superb 'QGoo' Java applet lets users warp, twist, bend and generally 'goo' any face with hilarious results. The applet can be downloaded free from **www.acko.net**

The 'Punch' gallery

FLASH

Increasingly, entire websites are being authored using Macromedia Flash, a sophisticated program for creating vector-based graphics and animations. It's not an easy or cheap program to learn, but its persuasive benefits – scaleable graphics, small downloads and user interaction – guarantee it a growing presence on the web.

PDF

Portable Document Format files offer consistent and precise control over layout and typography, over multiple platforms, making them particularly useful if your potential audience will be printing out forms and documents from your site. The downside is that PDF files need a plug-in and some pages can be hard to read onscreen.

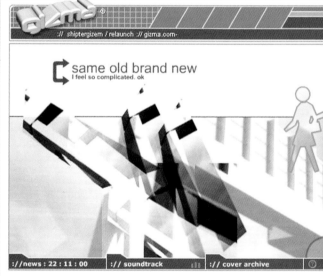

This is a personal site set up by 20-year-old Leeds-based student Nic Mulvaney to develop and share his Flash skills. Although complex interfaces like these rarely work for mainstream public sites, for showcasing graphic skills it's a great way for new designers to get noticed.

http://gizma.com

HTML RESOURCES

↗ **WEB:**
www.webtools.com/
www.htmlcenter.com
www.wdvl.com
http://tips-tricks.com/begin.html
www.webmaster-resources.com
http://hotwired.lycos.com/webmonkey/authoring/html_basics/
www.zdnet.com/devhead/
http://webreference.com
http://w3c.org
www.htmlhelp.com/faq/html/all.html
www.siteexperts.com/

↗ **NEWSGROUPS (USENET):**
Newsgroups are global discussion groups themed by topic, interest or locale, which allow users with similar interests to exchange and share information. There are something like 50,000 different newsgroups, all of which can be browsed using software like Outlook Express and Forte Agent. There's a useful guide for setting up newsgroup software at:
www.newsreaders.com/guide/
Archives can be viewed online at: **http://groups.google.com/**
Help to configure your Newsreader at:
www.usenet.org.uk/ukpost.html

↗ **ALT.HTML**
comp.infosystems.www.authoring.www
comp.infosystems.www.authoring.stylesheets
comp.infosystems.www.authoring.cgi
comp.infosystems.www.authoring.html
comp.infosystems.www.authoring.site-design

BUILDING ACCESSIBLE WEBSITEs

One of my favourite sites has a notice on the home page saying, 'this page best seen… if you come round my house and look at it on my monitor.' A bit silly perhaps, but it's a very valid point – you can never be sure how your site's going to look – some people may be accessing it through text-only screens, with older or non-standard browsers or using specialist software to counteract disabilities like text-to-speech browsers.

With this is mind, the W3C's Web Accessibility Initiative **www.w3.org/wai** has issued a comprehensive set of guidelines on how to make your site open to as many people as possible.

In some cases, accessibility may well become a legally enforced issue. In the UK, the Disability Discrimination Act (1995) ensures that providers of a service cannot discriminate against people by reason of their disability. Although no cases have yet been brought to court, many feel that it is only a matter of time – after all, why should some people be excluded from enjoying the web like everyone else? In the US, certain states already have legislation in place that can punish information sites for not reaching a high enough standard of accessibility. Further legislation is expected to follow in the US and EU.

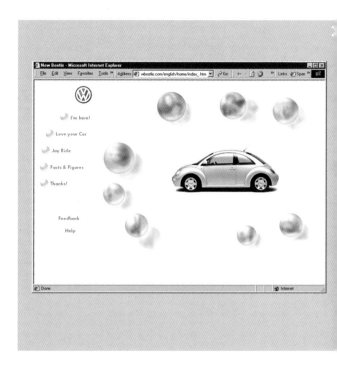

STEVE**DOUBLE**

ONLINE PHOTO GALLERY - DECEMBER 17 2000

photogallery \ biography \ credits \ copyright

Contact Steve Double

This is v2.1 (4+ browsers).
For v2.0 (no dhtml) click **here**.

88 . **Thom Yorke - Radiohead** musician.band

31 . **Eminem** musician

Thoroughly reprihensible,
produced Marshal Mather
possesing a gift for storyt
offend as many decent pe
who have responded in th
One suspects that in actu
screwed as obscurity bec

Some of the biggest companies in the world are guilty of building inaccessible websites. This New Beetle site is a mess: the blurry icons tell you nothing and the lack of ALT text attributes is unforgivable:

www.newbeetle.com/english/home/index_.htm

www.newbeetle.com

Sensibly offering two versions for those on older browsers, Steve Double's DHTML-authored portfolio site shows off his professional photographic work to great effect.

The clean, functional and straightforward design makes it a pleasure to navigate, with captions being made available by putting your mouse over the photo.

www.double-whammy.com

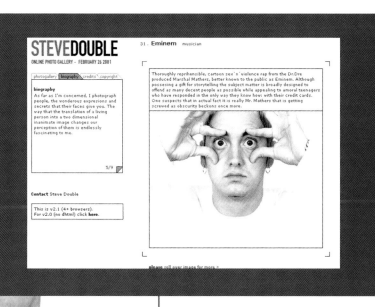

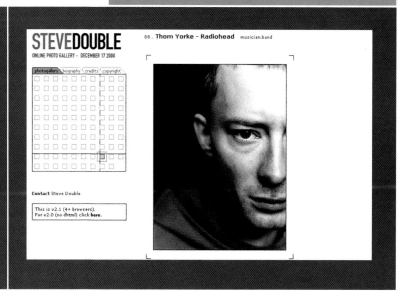

HOW TO MAKE YOUR PAGES MORE ACCESSIBLE

BACKGROUND COLOUR

Choose a single, solid colour; avoid swirly textures, garish photos and 'I've just dropped a tab of acid' backgrounds. Make sure there's good contrast between the background and the text. Check this by converting a screengrab of your page into a greyscale image. Don't put red text on a green background or vice versa – not only does it look crap but it won't make sense to 8 percent of the population who are colour-blind. The Vischeck colour blindness simulator lets you view how your site may look to colour-blind users, and also offers a downloadable Photoshop plug-in.

↗ http://www.vischeck.com/

LINKS

All links should contain enough useful information about their destination to make sense on their own – so filling up a page with 'click here' links isn't going to help anyone! Use 'link titles' to give users a preview of where the link will lead via a pop-up window. Here's an example:

order the book here

Include a text-based site map and don't have links directly next to each other as some access technologies will interpret them as being a single link.

TYPE

If you have to use graphics for headlines, ensure that a plain text version is available so that users can enlarge type if necessary. Go easy on italics and CAPITALS as they can be difficult to read. Use relative font sizes in your code, not absolute font sizes. Some browsers can't over-ride absolute font sizes.

IMAGES

ALWAYS use alternative text attributes ('ALT text') to describe your graphics and make sure it says something meaningful e.g., ALT="photo of Cardiff City holding the FA Cup, 1927". The only exception is when the graphic is used for purely formatting purposes, in which case use, ALT="".

For important images that contain a lot of information (i.e. a chart, table, or diagram) you may need to include a far bigger text description than can be reasonably accommodated in ALT text. Using the LONGDESC attribute of the IMG element, it's possible to access more detailed text, either included in the page or in a referenced separate page. For example:

Unfortunately, most current web browsers do not yet support the LONGDESC attribute. **www.cast.org/bobby/** recommends using both the LONGDESC attribute and following the image by a descriptive (or 'd') link. The 'd' link is a way for you to link manually to the target of the LONGDESC text:

** d

FRAMES

If you must use the things, always offer meaningful NOFRAMES content for those people who cannot read framed information. Don't just slap in, 'upgrade your browser', but include informative content with links to the other pages in your site, so that they can be accessed without frames.

Ensure that each frame has a sensible TITLE (in addition to the NAME) which gives a clear indication of the content to be found in that frame.

TABLES

Take care when using complex table layouts which may make little sense when read out by an audio browser. Use **<th>** tags to label each column.

FLASH/PDF

If documents are provided in Portable Document Format (PDF), ensure that HTML or plain text versions are also available.

Always provide plain HTML alternatives to Shockwave/Flash/Java widgets so that everyone can access the information and services on your site.

If your site has a Flash movie introduction, ensure a plain text link is available to enable users to access subsequent pages of your site.

Browser detection scripts may tell you that someone has Flash installed but that doesn't mean they want to see it. Always ensure that the user can choose between a Flash and a non-Flash version of a page.

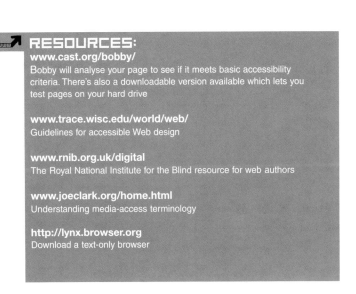

RESOURCES:

www.cast.org/bobby/
Bobby will analyse your page to see if it meets basic accessibility criteria. There's also a downloadable version available which lets you test pages on your hard drive

www.trace.wisc.edu/world/web/
Guidelines for accessible Web design

www.rnib.org.uk/digital
The Royal National Institute for the Blind resource for web authors

www.joeclark.org/home.html
Understanding media-access terminology

http://lynx.browser.org
Download a text-only browser

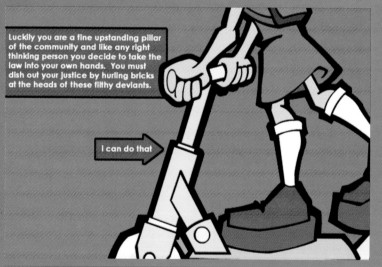

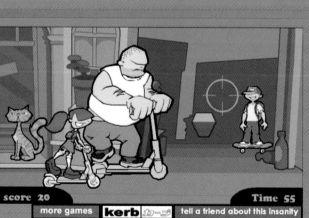

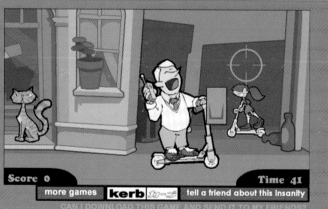



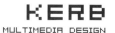
AUTHORED IN FLASH BY BRIGHTON-BASED DESIGN TEAM KERB, THIS FLASH GAME IS A CLASSIC EXAMPLE OF VIRAL MARKETING: TOPICAL, FAST, FUN AND IRREVERENT.

'Micro Scooter Death' invites users to score points by lobbing bricks at passing 'dickheads on fold-away scooters' with penalties deducted for hitting innocent bystanders. A high score table encourages repeat plays with players being invited to challenge friends, join Kerb's mailing list or play more games.

Kerb head honcho Jim McNiven explains their motivation for creating the game, 'we got a little tired of 'cutting edge' brands bottling out of doing stuff that's a bit twisted, so we just thought what the hell, let's show them what happens when we get carte blanche to do what we like.'

The result was a deluge of online and offline publicity, 15,000 unique users in the week it went live, all achieved with an advertising budget of zero and seeded from a mailing list of 200 people. Pretty successful, then.

'This', Jim continues, 'is viral marketing as it should be. The message is spread by people having fun instead of cluelessly spamming 10,000 addresses'.

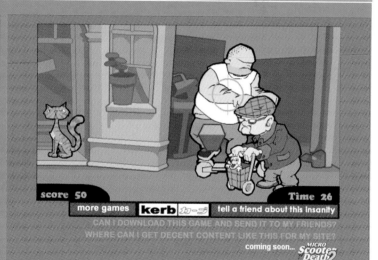

02 >

02
PLANNING AND BUILDING A SITE

Deciding on what kind of site you're going to build is obviously a mighty important decision and not one best made after a night out in the pub. Take time out to weigh up your objectives: are you hoping to sell goods or services, promote yourself or your company, provide an online resource or just show the world what a wacky and crazy dude you are?

If you're starting off in web design, consider building up your portfolio by doing a freebie site for a local charity, campaign or store – but make sure you're given enough freedom to experiment. If major traffic is your aim, bear in mind that the web's no different to the real world where entertainment, freebies, information and, of course SEX will always manage to grab people's attention.

Talk to friends and colleagues about your plans, ask for feedback and listen to their suggestions. Keep your plans realistic and achievable. It's far better to start with a small, concise and regularly-updated site that can deliver on its promises and grow as time and budget allows.

Running a website can take up a lot of time and energy, so unless you have a real enthusiasm for the subject matter, your site will quickly become stale, unloved and unvisited.

Last updated: Monday, 05-Mar-2001 10:22:28 EST Now: Monday, 05-Mar-2001 17:56:10 EST

No sweat!

The UK campaign against sweatshops

Nike? Gap? No sweat!

No sweat! was launched in November 2000 as a campaign against sweatshop labour, both overseas and in the UK. Panorama had recently screened an expose of *the Gap* and *Nike*, two huge rich multinational companies that are building a name as ruthless exploiters of child and sweated labour.

Both companies claim to be opposed to oppressive labour practices; they even claim to be "market leaders" but the programme revealed children as young as 12 working seven day weeks, for up to 16 hours a day.

No sweat! exists to fight the sweatshop profiteers.

Whether you work for McDonalds, Nike, Magnet Kitchens or the London Underground, your bosses exploit you for profit. We know that workers in today's capitalism have few rights, and we're determined to put that right.

We will be organising meetings, petitioning, protesting, unionising our workplaces and taking direct action - whatever it takes to put a stop to this exploitation. **Join us!**

New: the *No Sweat!* mailing list

Sign up now for the *No Sweat!* mailing list.

Enter your email address below, then click the 'Join List' button:

[] **Join List** LISTBOT

Enter *No Sweat!*

The *No Sweat!* website is yours to contribute to.

You can post messages, discuss tactics, advertise an event, or just sound off - we're listening. To post messages in the site, you need to login - and to login you need to register as a 'user'. If you've done that already, login now:

Login

Create a 'User ID'

If you just want to browse the site, you can - but you won't be able to post or edit any messages.

Look at the site

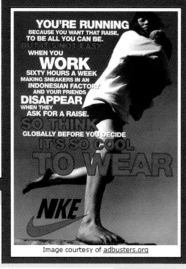

Image courtesy of adbusters.org

The web can gives anyone a voice, regardless of their budget. Campaign sites like this reach out to a global audience and forge alliances with similar campaigns worldwide.

www.nosweat.org.uk

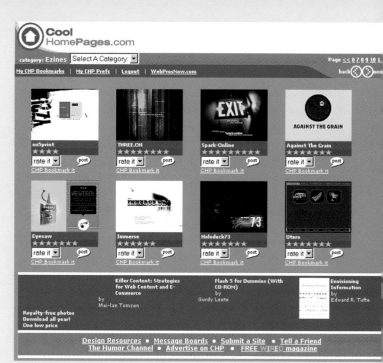

This is a great place to check out the work of other designers and - hopefully - find some ideas for your own site!

www.coolhomepages.com

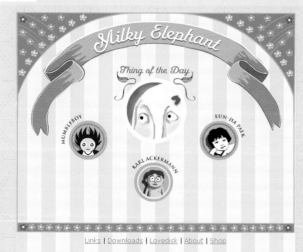

This acts as a portfolio and experimental site for the work of three designers. Simple stories are told through pop-up windows and audio samples.

www.milkyelephant.com

TYPES OF WEBSITE

Websites can either be made up from static HTML files served up from a database, or be dynamically created.

If your pages only need to be occasionally changed, a fully-fledged, database-driven site would be over the top, but for regularly-updated news sites, e-commerce sites or pages demanding large amounts of user interaction, a database-driven site makes life considerably easier. A custom database can take a hefty chunk out of a company's budget, so it's important to fully research the systems on offer and try to account for future growth.

If you've a king-size budget and a team of technical whizzos, it's possible to set up smart dynamic sites that can serve up targeted, customised information to visitors based on their previous visits to the site. Software algorithms can even cross-reference this information with the preferences of users with similar interests to suggest interesting content. Of course, not everyone needs this level of wizardry and many sites can keep their visitors more than happy by offering a mix of static pages and simple areas of interaction like polls, bulletin boards and chat rooms, most of which can be incorporated into your site for free.

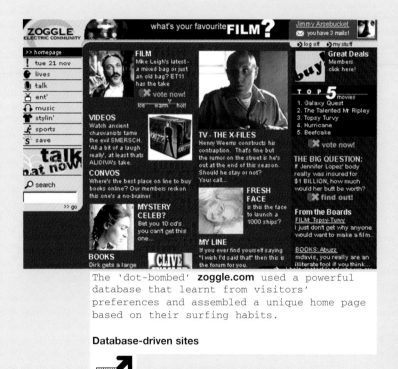

The 'dot-bombed' **zoggle.com** used a powerful database that learnt from visitors' preferences and assembled a unique home page based on their surfing habits.

Database-driven sites

HOSTING YOUR SITE

Before you can get started on your site, you'll need to host it on a computer that's permanently connected to the web, called a web server.

Although web servers are just simple computers running specialist software, managing your own would be a formidable and daunting task. You'd need an ultra-fast, cash-sucking permanent connection to the internet, a team of techies hanging around the house all day to maintain the machine and hefty backup systems in case of power-cuts and system crashes. You'd also have to be permanently on the look-out for dastardly hackers whose idea of a wild night out is to inflict all manner of unforeseen system abuses and do their best to change your company logo to, 'We Suck Ass Inc.'

If, by chance, your site grows in popularity, you'll need more powerful servers to handle the load, possibly ending up with huge server farms, consisting of masses of computers all linked together. And, worst of all, yet more techies munching pizza and spilling coffee all over your carpet.

So, running a web server is really only a job for big companies and those strange individuals who can't get enough of fiddling about with computers. To save yourself all this hassle, it's usually best to rent space on someone else's server. This service is known as 'hosting' and although many use the space offered by their Internet Service Provider (the service they use to dial into the internet) there's no reason why they can't rent the space from other hosting services.

Ask for recommendations (some hosts are definitely better than others) and check out the performance listings to be found in many monthly internet magazines. Sites like **www.thelist.com**, **www.ispreview.co.uk/** and **www.webhostlist.com** offer updated information on ISP performance.

ADBUSTERS CAM

SPOOF ADS

www.adbusters.com

www.adbusters.com

The usual deal is to pay a monthly fee to your host and they make your website available on the web. There are freebie hosting services on offer (like → **www.geocities.com**, → **www.xoom.com**, → **www.tripod.com** etc.) but these offer very basic services and often inflict horrid banners and floating pop-up boxes on visitors. Many of these services also tie you to their set of procedures and rules and limit the amount of webspace and bandwidth available.

Bandwidth relates to the amount and size of files transferred off their server – the busier a site, the higher the bandwidth used, particularly if the site has lots of heavy graphic and multimedia files. Many hosting companies set upper limits, closing down your site if you exceed this amount. My own site, → **www.urban75.com**, was unceremoniously booted off its original home on demon.co.uk after an unexpected overnight appearance on prime-time US TV set the hit rate soaring into the stratosphere. I woke to find 2,000 emails waiting for me with a note from the ISP telling me they were closing down the site!

For this reason it's important to chose your web host very carefully and be mindful of your needs: if you expect your site to attract huge amounts of traffic, be prepared to pay a premium for webspace with no bandwidth restrictions – and be sure to read the small print carefully. Make sure your host offers decent telephone support too – if they can't be reached at 2am when your site goes down, you'll lose a lot of customers working in different time zones. Some hosts charge ludicrous fees for telephone support, so be warned!

People expect websites to be regularly updated, so you'll need full and unrestricted access to your site files – some hosting deals only let you make a limited amount of changes per month or charge you to make changes. Updating and uploading new files to your website is fairly simple, but make sure your web host offers full FTP and Telnet access to your server – insist on it.

www.once-upon-a-forest.com

www.once-upon-a-forest.com

www.once-upon-a-forest.com

Often, your site won't have its own server but will share the space with several other sites on the same machine (known as a 'virtual server' account – a 'dedicated server' is where the server only hosts your site).As you're sharing server space you'll only have access to your folder (HTML files, image files, etc.), often called the 'htdocs' directory. Some hosting deals let you add or use specialist software and scripts like Cold Fusion, CGI and FrontPage extensions, often charging you extra for the privilege.

Lastly, if you're using the free space provided by your ISP, you'll probably have a rambling URL with lots of dots, dashes and even these things: '~'. Not only are these kinds of addresses devilishly hard to remember but they give out an unprofessional image, especially if they feature words like 'freespace' in the URL. If you decide to change ISP later, you'll also lose your address – and all the visitors who have bookmarked your site in the past. It's always best to get your own domain name – I'll tell you how to do that later.

This interesting and popular collection of aural samples and Flash trickery makes it a worthwhile bookmark.

www.once-upon-a-forest.com

UPLOADING/FTP

Most web authors build and test their sites on their own machine first, and upload the entire thing when it's finished, adding new pages and updates when necessary. To transfer files from your hard drive to the web server and vice versa you'll need a piece of software that lets you use File Transfer Protocol (FTP).

Some packages have this facility built in (Dreamweaver, Homesite, FrontPage) but many designers prefer the extra flexibility of using a dedicated piece of software, known as an FTP client. The most popular of these being CuteFTP
↗ **www.globalscope.com**, WS-FTP
↗ **www.ipswitch.com**, Anarchie [MAC] and Fetch. Most work the same way: you go online, open up the program, type in the name of your server (e.g. cheapospace.com) and the login name and password you were given by your hosting

service when you set up your account. Bash 'connect' and the FTP client should connect with your web server and present you with two windowpanes, one displaying the contents of your own hard disk, the other showing the files on the remote computer (the web server). You can then upload new files from your machine to the web server. This is usually done by simply dragging and dropping them into the server window.

Don't go mad and post up all your half-baked, experimental pages, as you might end up running out of server space. Even worse, these pages might end up being added to search-engine databases, so as a rule, keep everything out of the 'htdocs' directory of your Web server that you don't want the public to see! It's usually easiest – and prudent – to keep an exact copy of the site on your local hard drive and maintain a second or third back up too, just in case. Sooner or later you're bound to overwrite the wrong file or suffer some other kind of calamity – it happens to everyone!

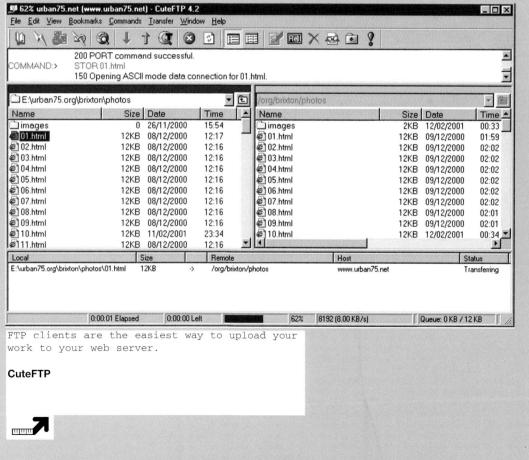

FTP clients are the easiest way to upload your work to your web server.

CuteFTP

DOMAIN NAMES

Once you've decided on somewhere to host your site, you'll need to come up with a domain name. Ideally this should be short and snappy, memorable, hard to misspell and related to your company name or core business. This will make it easier for people to find and remember your site, add a bit of credibility to your company and help reinforce your name and branding. It'll also help you get higher rankings with search engines who favour sites with keywords in their name.

Unfortunately, since most words and names have already been used, you'll need to get imaginative – this may involve renaming your company, dreaming up a particularly daft name or being lumbered with a lengthy moniker. Be careful with how your name looks and sounds, and consider its international meanings – www.cheapfags.com has entirely different meanings in the US and UK! Try to avoid dashes, although they can be useful: if I'd decided to call this book 'Hits! Hits!', I may well have gone for a domain name of www.hitshits.com, which might well be open to a different interpretation. Calling it www.hits-hits.com would have made the name much clearer.

CHECKING THE NAME

Once you've decided on a likely name, it's time to see if it's available. There are several websites offering a 'who is' service which lets you find out what names are taken **www.betterwhois.com**, **www.allwhois.com**. On most you can buy domain names immediately, so have all your details ready – and your credit card! It's highly unlikely your first choice will be available (unless your company is conveniently called zz3x6z8zty.com!) so have a list of alternatives. Names can go fast, so if you find a half-decent name don't expect it to be there tomorrow. Grab it now!

Many ISPs and web hosts offer to take care of the registration process for you, for a fee – although it's not that hard to do yourself if you have a little technical knowledge. Be very wary of the super-cheap bargains – the host company may end up owning the domain name themselves and charge you a bomb if you want to move servers later. Many of these cheapo domain deals also involve search engine-unfriendly techniques like redirecting, masking and branded hosting. If you're serious about your site, avoid them.

www.artistica.org

Occasionally updated, artistica.org features the work of young creative designers, showcasing original fonts, graphics, comics and experimental work.

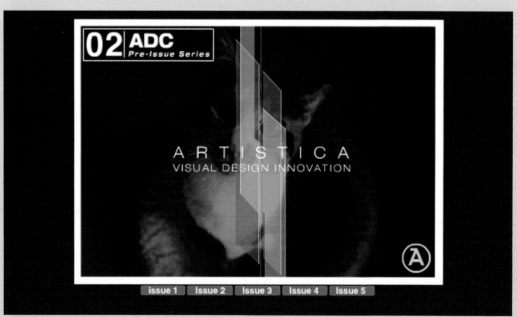

HOW DO DOMAIN NAMES WORK?

Each website has a unique IP address, which looks something like this, '192.56.7.10'. To save you having to remember lists of scrambled numbers, a system was set up where people could type in easy-to-remember words and/or numbers and these would be automatically converted into IP addresses using Domain Name Servers (DNS).

TOP-LEVEL DOMAINS

These were set up with the intention of defining the type of company or enterprise, and anyone could apply for them:

.com Designed for companies or commercial enterprises.
.net Intended for network providers and their computers.
.org Miscellaneous and not-for-profit organisations.

Four other top-level domain names were set up and these were restricted for specific situations:

.int Used for international databases/organisations established by international treaties.
.gov Originally for government agencies, now only for US federal government agencies.
.mil US military.
.edu Four-year colleges and universities

(at the time of writing there were several new top-level domain names awaiting approval, including **.aero**, **.biz**, **.coop**, **.info**, **.museum**, **.name** and **.pro**)

In addition, country codes were created to distinctly identify the nation in which the domain name was registered, e.g. **.uk** for United Kingdom, **.de** for Germany (Deutschland), **.ru** for Russia etc. Although some country code top-level domains insist on residence requirements, others have no restrictions, resulting in anomalies like the little-known island nation of Tuvalu suddenly acquiring international popularity because of its popular '**.tv**' suffix.

DOT COM

The most prestigious and sought-after domain suffix is the dot com which, because of the early American dominance of the Net, is now seen as the address for commercial organisations (the fact that most popular browsers automatically add '.com' to words typed in an address box makes it all the more appealing). Such is the perceived value, it's not unusual for companies to rename themselves to whatever dot com address is available. As a result, almost every single possible permutation of the English language has been registered as a dot com, often by greedy companies ('cybersquatters') hoping to make a quick buck by selling on the names later.

For commercial enterprises, it's good practice to register the same name with several different domain suffixes to make sure customers find them, and in the case of the more popular companies, some of the more likely misspellings (there's already a long tradition of porn sites being set up to grab traffic from people mistyping URLs).

Although it makes sense for sites with an international user base to use .com addresses, it's inappropriate for sites dealing with local content or selling goods and services locally.

COPYRIGHT

.com officially denotes a US site, so be careful to check your domain name for possible copyright or trademark infringement with US-based companies. If someone's taken diabolical liberties with your brand or trademark, check out **www.icann.org** for more information.

PRIVACY

Be aware that the details you entered when you registered your domain name are readily available to the public. Use your business or a forwarding address for safety.

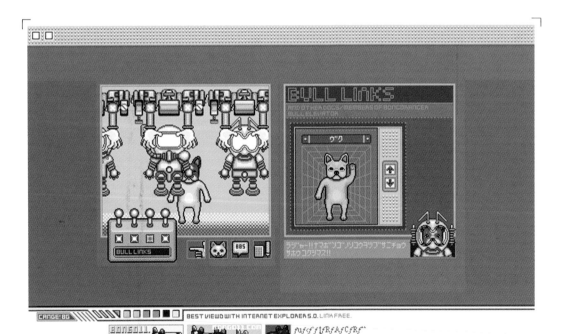

DOMAIN NAME RESTRICTIONS

Top-level domain names (**.com**, **.net**, **.org**) must be between three and 60 characters in length (excluding the characters '.com').

Second Level Domain Names (**.co**, **.uk**, **.org.uk**, **.ltd.uk**, **.plc.uk**) must be either a minimum of two characters with one character being a number, i.e. 3 x.co.uk, or a minimum of three letters. The maximum length, excluding the '.co.uk' part is 64 characters.

RESOURCES:

DOMAIN NAME INFORMATION:
www.workz.com/content/401.asp
www.domainsillustrated.com/knowledge/intro2_1.asp
www.gtld-mou.org/
www.hotbot.lycos.com/help/domains.asp

CHECKING FOR U.S. TRADEMARK VIOLATIONS/ ALTERNATIVE FOREIGN LANGUAGE MEANINGS:
www.e-gineer.com/domainator

SUGGESTED VARIATIONS BASED ON KEYWORDS AND BUSINESS NAME:
http://rwm.net/virtualis/domainwizard

I can't say I had the remotest idea what was going on here - animated dogs donned spaceman suits, bones were thrown from a boat into giant cat's heads and cats waved from a skyscraper. Fantastic stuff!

www.bongo11.com

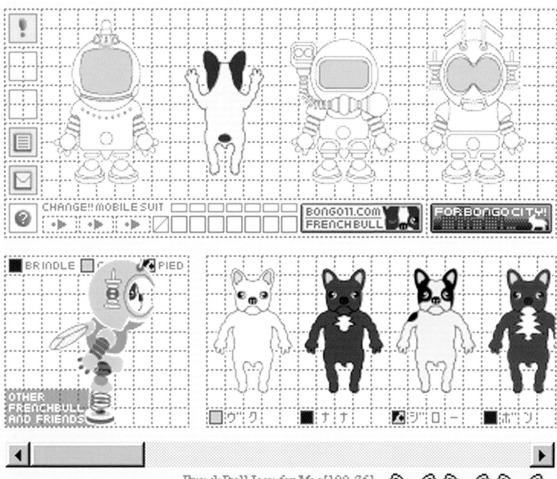

CHANGE!! MOBILE SUIT

BONGO11.COM
FRENCHBULL

FOR BONGO CITY!

BRINDLE ☐ C____ ☑ PIED

OTHER
FRENCHBULL
AND FRIENDS

☐ ウ゛ク ■ ナ ナ ☑ ジ ロ ー ■ ホ゛ン

FrenchBull Icon for Mac [100-76]
at the BongoStore 2F
[Sorry! MacUser Only]

Select your mad creature at the home page of Bongo 11.

www.sam.hi-ho.ne.jp/bongo/

WITH OFFICES SPREAD ALL OVER THE WORLD, DEEPEND ARE ONE OF THE NEWEST AND MOST SUCCESSFUL DESIGN AGENCIES. DESCRIBING THEMSELVES AS BEING AT THE 'COAL-FACE OF UNDERSTANDING AND IMPLEMENTING ORIGINAL MATERIAL IN MANY TECHNOLOGIES', THEY CAN BE RELIED UPON TO PRODUCE INTERESTING AND CHALLENGING WORK. WELL, MOST OF THE TIME, ANYHOW.

HOW DO YOU APPROACH DESIGNING A SITE FOR A CLIENT?

The first part of client relationships is understanding who we all are and what we are all capable of. Trust is the biggest hurdle in this relationship and it is a difficult thing to timetable; but with it you can tear up the briefs, work in the freedom of failure, and deliver something together that you were not capable of apart.

WHAT MAKES A GREAT CLIENT AND WHAT MAKES A NIGHTMARE CLIENT?

Again, trust. Plus the ability to make decisions and stick with them. That's what makes a great client. Bad ones can't and don't want to listen.

WHAT'S YOUR OPINION ON: (A) DESIGN VS. DOWNLOAD TIME?

The pain threshold between wait and watch is always a personal thing. It's like flirting; you can wait and tease for a long time, but if you don't deliver what you promise, then it leads to disappointment all round and they won't ask you out again.

(B) LATEST TECHNOLOGY OR MAXIMUM COMPATIBILITY WITH DIFFERENT/OLDER BROWSERS?

I hate compatibility issues; they don't crop up anywhere else. If you get it right no-one sees it or is grateful; get it wrong and you are a fool. It's an unfair waste of designers' and programmers' time. The latest thing on the block will always excite the few pioneers, but human nature has always been that way. If you have to deliver a mass message then you have to operate in mass markets.

(C) ACCESSIBILITY: MANY OF THE NEW TECHNOLOGIES COMPROMISE ACCESSIBILITY. IS THIS INEVITABLE OR ARE DESIGN COMPANIES NOT DOING ENOUGH?

You have to be platform-neutral these days. You can never bet on the favourite as you can guarantee it will be shot in the head yards from the finish-line. Our industry has its roots in technical advancement but we need the audience to keep up.

(D) COMMERCIALISATION OF THE WEB – UNAVOIDABLE? A DISASTER? MAKES NO DIFFERENCE? OTHER..................?

We are designers; we sell our services, not just our work – that's what artists do. Commercialisation is a flexible master if you're calling the shots; and our independence allows us to do exactly that.

ANY TIPS TO DESIGNERS STARTING OUT ON THE WEB? WHAT ARE YOU LOOKING FOR IN A NEW DESIGNER?

First tip: buy a tight belt and be prepared to go hungry for a while. It's a very competitive market and some very good people are walking the streets. Find your true passion and go for it however you can to make ends meet.

FAVE SITES:
www.volumeone.com
www.google.com
www.jibjab.com

Simon Waterfall,
Creative Director, Deepend

03

USING INFORMATION ARCHITECTURE TO BUILD A PROFESSIONAL SITE

What is information architecture? Although it sounds like a new-media buzz word it is actually an important part of the process of building a site. It is the process of working out what you want your site to do, how it's going to do it and making sure it's all going to work before building the thing.

On complicated sites it can be a real challenge finding out the best way to organise the content and functionality while trying to keep the client, the techies, the designers, the marketing folk and, of course, the target audience, happy. But it has to be done: sites can only start to be built after the project's structure has been firmly nailed down – mistakes made here may cost a fortune in time and money later.

Although the example process here is geared towards building a commercial site, the basic rules are exactly the same for any site.

DOCUMENT IT!

In the excitement of putting together a new site, it's easy to forget about documenting everything until it's too late. Don't!

Documenting the site's goals, agreed timetables and production schedule is an essential part of the process which should help keep you and the client in accord. Whenever something is agreed or amended, write it down and distribute copies. Make sure everyone's kept in the picture as the site progresses and, if you do it methodically, you'll be covered if things go wrong later!

Illustrator Paul Davis's astonishingly original site uses a mix of JavaScript and straight HTML to deliver a unique experimental site, proving an ideal vehicle to show off his design flair and sense of humour. Pop-up windows interact with each other and deliver graphics, slogans, witty puns and sound samples.

www.copyrightdavis.com

DEFINING THE GOALS

The first step is to clearly define the site's goals. Apparently obvious, but get a few designers together and they'll soon be sharing stories about long meetings with nightmare clients who spent the entire time arguing amongst themselves about what the site should do.

Conversely, it's also not unusual to meet clients who insist their company needs a site, but when asked what they want it for, look back at you with a lost puppy expression, as if to suggest, 'we thought you'd know.'

Cut though the crap by finding out who the key players are and set up a timetable of meetings to thrash out an overall strategy for the site. Once you've got everyone together, ask them the following questions to make sure everyone's 'singing from the same song sheet' (as some ghastly marketing type might put it).

WHAT IS THE PURPOSE AND MISSION OF THE COMPANY?

This should get a straightforward and concise answer – start to panic if it doesn't! Gather background information about the company before the meeting: yawn through any promotional literature and take a look at their existing website (if they have one), paying particular attention to any 'mission statements' you find.

WHAT ARE THE SHORT AND LONG-TERM GOALS?

You'll be amazed how many different answers you can get to this one, with some people only being able to see as far as the middle of next week, while others seem to revel in empire-building, decade-spanning meisterplans.

WHAT IS THE SITE FOR?

Some clients have this quaint notion that the mere act of putting up a site will somehow send sales figures soaring. The reality is that simply sticking up a corporate brochure is not enough. Unless a company develops a coherent web strategy that targets a specific audience, their site will remain untroubled by visitors.

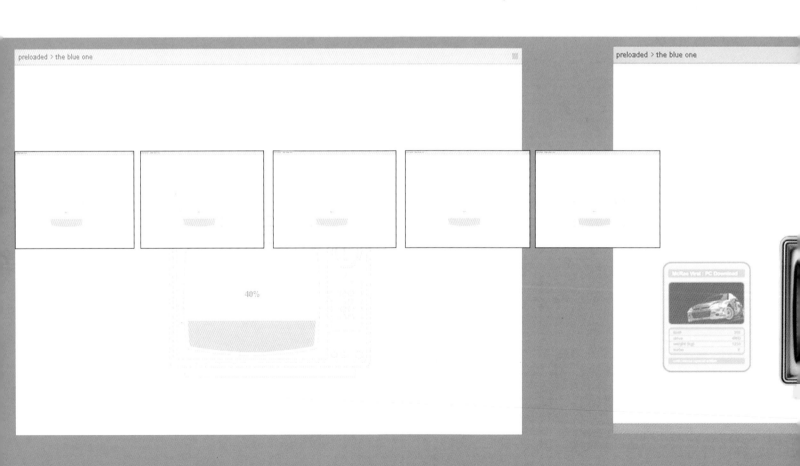

WHO IS THE SITE FOR?

Ask them who their target audience is and why they should be coming to their site – after all, if someone's already built a site on the same subject, why should anyone bother looking at theirs? What will their site have that can't be found elsewhere and what will make people come back?

WHO IS THE COMPETITION?

Get them to list who they view as their competitors. Type in keywords related to their proposed site in search engines like ↗ **www.google.com** and see if any other similar sites come up. Review the sites together and check people's reactions to them. If some of the sites have good ideas, discuss how they might be improved on their site. It's also worth finding out what others are saying about competitors and a great place to dig up the dirt on them is in the Usenet discussions archive at ↗ **http://groups.google.com**. Type the company name in the search box and see what comes up. Don't forget to look in the traditional press too, as that can provide a rich source of background information.

IS THE WEB THE RIGHT MEDIUM?

You might end up talking yourself out of a job here, but it's worth scrutinising their proposal to see if it really is viable. Is there already a hugely successful site on the same topic online? Would the web be the best use of their resources? How would a site fit in with their existing business? Although it's easy to get excited about the prospect of advertising goods and services on a global stage, are they really geared up to handle export orders?

Once you've got a clear idea of everyone's ideas, draw up a master list of site goals and present it to the big cheeses and chiefs of the project for discussion and, hopefully, approval. As soon as you gain approval from all concerned and get the client to sign off on the goals for the site, it's time to go for a beer – the site officially has a purpose and a set of goals!

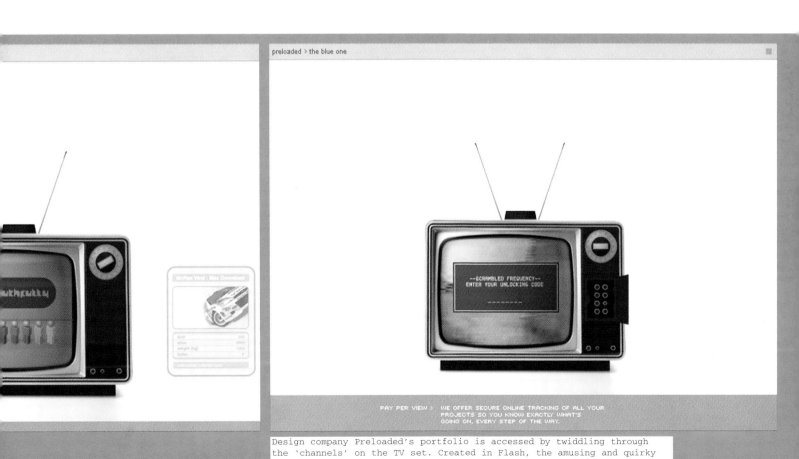

Design company Preloaded's portfolio is accessed by twiddling through the 'channels' on the TV set. Created in Flash, the amusing and quirky interface and attention to detail makes these guys stand out from the crowd.

www.preloaded.com

LET'S HEAR IT FOR THE USERS!

So now we know the goals of the site it's time to concentrate on the single most important thing that will make or break the site – the users. But who are they? Hopefully, the earlier discussion will have produced a list of intended audiences, now expand this list to cover every single possibility.

For example; imagine the site was being set up to promote a moderately successful rock band. Who might want to access it? There would be the band's fans of course, but what about record companies looking for new talent, DJs, music agencies looking for bands to go on tour, venues looking for acts, foreign festivals looking for bands, support bands looking for gigs, music papers wanting an interview, radio stations wanting to hear material, and so on. Get as many involved as necessary to contribute their own ideas – you might be surprised just how wide an audience a site may attract.

For every potential visitor, question how they might find your site – would they be able to discover what they are after easily? Would it provide them with the information they needed, and if not, why not?

It's important to consider how your audience will be accessing your site. Will it be head honchos of major corporations using super fast T1 connections (or slow mobile connections as they travel to work on the train), or will it be grannies at home on weedy 14.4 modems? How about technology? Are you going to force all users to install the very latest browser and download a fleet of phone bill-inflating plug-ins before they can access your site, or will you make it accessible to the widest audience possible?

With each scenario, you should be getting a better picture of the possible demands of users, and this knowledge should come in useful when planning the design and content of the site.

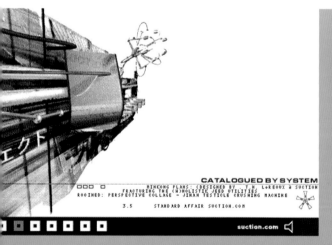

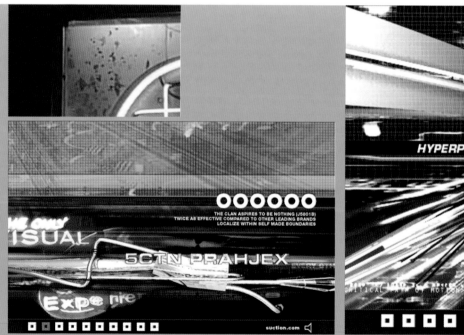

CONTENT IS KING!

Now that you've worked out the theme of the site and who your audience is, it's time to make sure that you can feed these hungry surfers with the content they want. Make a big list of all the content you're likely to produce; reviews, news pages, feedback, database-generated pages, bulletin boards, static pages, whatever – then think hard about whether you have the people and technical resources to deliver them. Most people usually start off with wildly ambitious plans, so be prepared to knock off any less-than-essential features and focus on the core functionality of the site.

Consider the technology you'll need to deliver the content – do you really need that user-customisable, state-of-the-art, spinning navigation module, or would static HTML pages suffice? Are there enough technical resources to build a custom database or would an off-the-shelf solution be more practicable?

Evaluate the administrative implications of each feature: and make sure you can deliver on your promises – a web site with a news section that's four weeks out-of-date is unlikely to impress visitors or give the impression of a happening company.

Lastly, watch out for 'scope creep'. This rather silly phrase refers to projects that have more and more non-core features and goals added to them until people have almost lost track of the original aims of the site. Keep it focused!

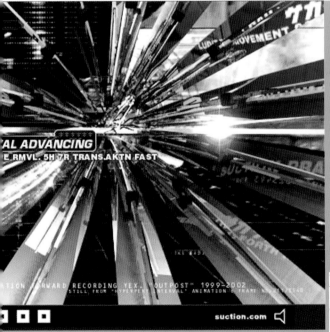

This online portfolio of graphic work uses a simple Flash navigation bar with sound loops.

www.suction.com

STRUCTURE THE THING!

After defining the content, define the site's structure. This is the process of organising the site into manageable sub-sections.

Ideally, these should each contain a roughly similar amount of content, so that users won't be jumping from sections overflowing with lively links to windswept pages containing a paltry selection. Try to anticipate growth and consider how extra content may be distributed in the future. Remember, the more sub-sections you throw in, the more likely you are to overwhelm the viewer, so a logical set of sub-groupings is vital to stop the navigation sprawling all over the page.

If you're selling stuff online, have the ordering page easily accessible – preferably just one click away from the home page: statistically, the more clicks it takes to get to the 'orders' page, the less orders you'll get.

SITE MAP

Now it's time to draw up the site map or site blueprint – heck, you can even call it the 'site structure listing' if you want to impress your clients. This is simply a graphical representation of how the site will be arranged, listing all the sections and their subsections, usually with the home page on the top. The more care you take over this, the easier it will be for everyone else to understand what's going on.

Specialised programs like Microsoft Visio can knock out very slick-looking site maps, but with bit of faffing around, your average word processor can do a reasonable job.

In the example diagram opposite, each box represents a web page, containing the title and a unique number to identify it (handy for later as titles often change).

The lines connecting the boxes indicate the primary linking structure, although each page may also contain a set of generic navigation links (they are usually omitted from site diagrams for the sake of clarity).

Accompanying the site map should be a site script; listing, in full detail, the features of each of the pages shown in the blueprint, including the page title, page file name, all the links from the page, the content and the standard header/footer information. Remember to date these site maps so that you can make sure everyone's using the right one!

Most websites are built on a hierarchical design, which looks a bit like a tree structure, with the main sections arranged as boughs, linking to smaller subsection branches below and so on.

Sequential site structures lead users through an author-defined path, often with a 'start' page and 'next' and 'back' buttons. These are great for guiding new users through a short introductory 'tour' of a large website or for short tutorials. However, basing an entire site on this structure would soon drive people up the wall – people like to view sites as they wish, and forcing them through a one-way linear path can be incredibly annoying – especially for users arriving mid-way through your tour via a search-engine link.

RESOURCES:
www.builder.com/Authoring/AllAboutIA/ss01.html
http://hotwired.lycos.com/webmonkey/design/site_building/tutorials/tutorial1.html
www.ala.org/acrl/resoct00.html

SEQUENTIAL SITE STRUCTURE:

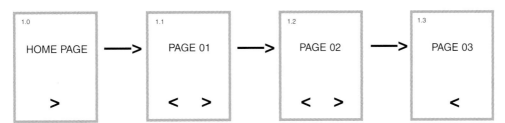

HIERARCHICAL SITE STRUCTURE:

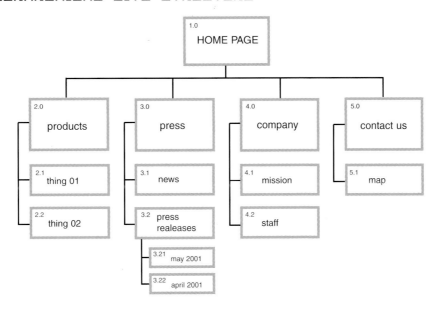

THERE'S OFTEN TROUBLE IN STORE WHEN COMPANIES TRY TO FORCE THEIR HIGH-STREET IDENTITY ONTO E-COMMERCE WEBSITES. E-COMMERCE SITES SHOULD BE FAST AND INTUITIVE WITH CLEAR NAVIGATION. BUT THIS EXAMPLE FROM ARGOS IS ALMOST A CELEBRATION OF BAD USABILITY.

Users first have to get past the pointless splash screen before being presented with a home page that seems to have been created to a design philosophy of 'scatter! scatter!'

Navigational elements are distributed far and wide over the page and come in all shapes and sizes. You want graphic, vertical, horizontal and text links, 3D buttons and drop-down menus? You got 'em!

Large vertical navigation strips on the far-left and right of the page needlessly waste valuable screen real estate, with some of the links being repeated in horizontal button form. Why the two vertical links on the left have graphics pointing to the third, unrelated, horizontal button is anyone's guess. Even more odd is why there's a vertical strip on the far-right imploring me to 'go to home' when I'm already there.

It gets worse: clicking on 'go to compare' leads to an impenetrable page that not only manages to be astonishingly ugly but utterly useless too... What I am supposed to do here?

In frustration, I reached for the 'how to navigate the site' choice from the pull-down menu. A pop-up window appeared, serving up the minimum of information via seven slow graphic screens (a combined weight of around 200k), each containing barely a paragraph of text. A simple text page would have been far better.

Trying to force offline branding into an online identity rarely makes for comfortable viewing, and although it may provide an initially familiar interface to the user, ultimately if they can't find what they want quickly, they'll go elsewhere.

Thankfully, Argos have since taken great strides to improve the site's functionality and appearance. Confusing features like the 'go compare' page have been removed and although there are still one or two key areas that could be improved, it's clear that Argos are willing to take on board usability issues and listen to customer feedback.

Now over 8000 products online

Shop online, free delivery when you spend over £100

Or reserve online & collect from your local store, with Click & Collect

Click here to enter the site

The splash screen does nothing but get in the way of users interacting with the site.

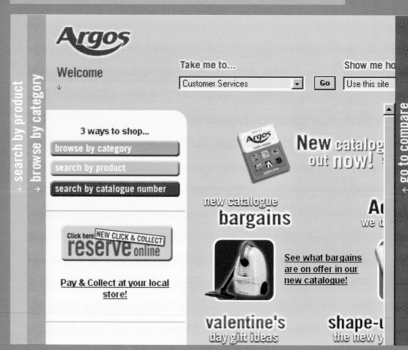

The frameset-based site falls apart on 640 x 480 screens, with users having to scroll up and down and across to find all the options.

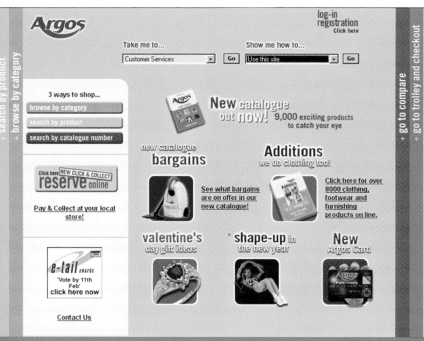

A confusing mass of assorted navigation bars and links greets visitors who are given no clear indication of a suggested route through the site.

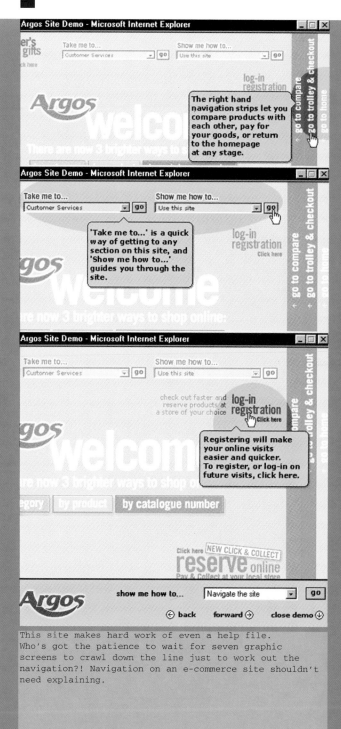

This site makes hard work of even a help file. Who's got the patience to wait for seven graphic screens to crawl down the line just to work out the navigation?! Navigation on an e-commerce site shouldn't need explaining.

Only one click away from the home page, this is the kind of screen that sends potential customers away screaming. What on earth is this page supposed to do?!

04

DESIGNING THE SITE

Designing for the web is a skill that can take years to master and is not something that comes free with a copy of Photoshop. A great knowledge of HTML has got nothing to do with design (as the painful results of many 'techie' websites will testify!), and some print and video based designers may have immense trouble adjusting to the minimal type, colour and layout controls offered by the web.

The importance of design should never be underestimated. A good-looking site will influence the user's initial perception of the site's value and encourage them to explore the site further. A tawdry, badly-designed front page may deter users from even entering, as might a design that looks completely inappropriate for the site's theme (so, no mud-wrestling ladies for the local church's home page, then).

FORM VS. FUNCTION

Successful web design demands an understanding of the primary components of a website: content, form, function and purpose. Finding the right balance between these has always been the trickiest of challenges. There's no hard and fast 'right' or 'wrong' way of doing things in web design, just what's appropriate for the site.

For most commercial sites, the primary focus shouldn't be on the interface – the spinning gizmos or funky graphics – but on the content and the task in hand. Everything is secondary to the content: if a site looks amazing but no one can figure out how to get around it, it's a failure. If the navigation is a wonder of modern engineering but only leads to pages of rarely updated content, people won't be coming back for more.

Some designers can't get enough of microscopic text, impenetrable interfaces, obscure navigational elements and deeply-concealed links that make getting through the site a feat worthy of celebration. Although these sites can provide an exciting and challenging environment for visitors who enjoy battling at the boundaries of web design, for others it'll be an irritating and exasperating experience that will have them reaching for the 'back' button sharp-ish. Such unconventional sites are great as design portfolios but totally unsuitable for most task-driven, frequent-use commercial sites. A well-built site should serve the needs of the user first and foremost, not the aspirations or egos of the designers or the commercial demands of the marketing folk.

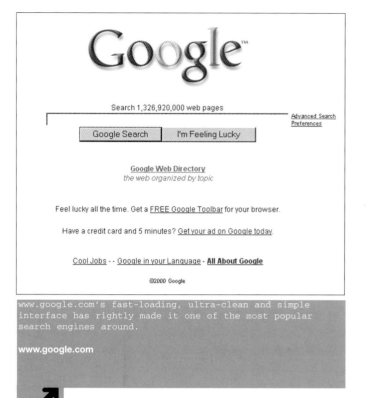

www.google.com's fast-loading, ultra-clean and simple interface has rightly made it one of the most popular search engines around.

www.google.com

This site was still 'under construction' when I looked at it, but the Flash experiments looked full of promise.

www.wireframe.co.za

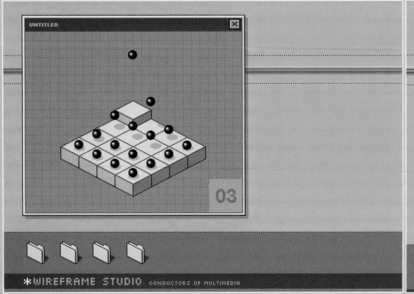

simple sex site
a free adult information services provider

topics

(hold CTRL key for multiple selections)

status

- brunette
- buttocks
- celebrity
- ebony
- ejaculation
- fellatio
- fetish
- fisting
- gastronomy
- group

AND ⦿ OR ○

search topics

simple sex site
a free adult information services provider

home

search results

displaying 1 - 26 of 87			next 25
buttocks amateur	report bad link	email link to...	source
buttocks amateur	report bad link	email link to...	source
buttocks amateur	report bad link	email link to...	source
buttocks amateur	report bad link	email link to...	source
model buttocks	report bad link	email link to...	source
teen buttocks blonde amateur model	report bad link	email link to...	source
teen buttocks blonde amateur model	report bad link	email link to...	source
teen buttocks blonde amateur model	report bad link	email link to...	source
teen buttocks blonde amateur model	report bad link	email link to...	source
teen buttocks blonde amateur model	report bad link	email link to...	source

www.simplesexsite.com gets down to business in no uncertain terms, using a fast, simple menu system to let users select their specific requirements!

www.simplesex.com

The bearded lady's interface looks like a new operating system, with users being able to open, close and drag windows around the screen.

www.thebeardedlady.com

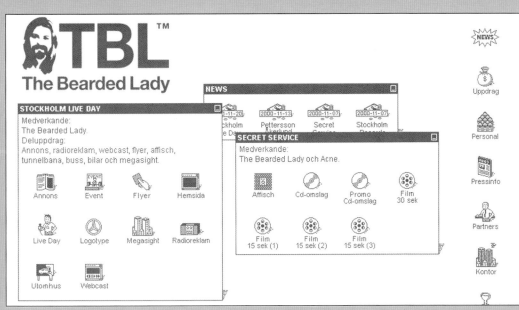

DESIGN ISSUES

Once you've decided on the appropriate treatment for the site, it's time – at last – to get creative!

Use whatever medium you feel most comfortable with to sketch out ideas and concepts for the site. Just because you're using a computer to make the site doesn't mean all the graphics have to be created there: get off your butt and take photos, scan stuff in, find weird textures, make up new typefaces and even (gasp!) get out your pens and draw something.

Give yourself time to experiment and to try out all kinds of ideas. Sometimes the maddest beginnings can produce the best solutions, so have fun! Most of all, don't be afraid to rip it up and start again if something's not working: there's no point wasting time over a design that doesn't gel.

If you get really stuck for ideas, try to draw inspiration from all kinds of media – not just other websites. Use art, photography, graphic design and print books, record sleeves, flyers, labels, graffiti – whatever! – for inspiration when the going gets tough.

If you're not confident about your design skills, it's always best to keep it simple – very simple indeed – and concentrate on presenting the content of the site. If it's a commercial site, think long and hard about whether you really have the right skills in-house: just because the bloke who fixes the hard drives knows HTML that doesn't mean he's capable of designing a good site.

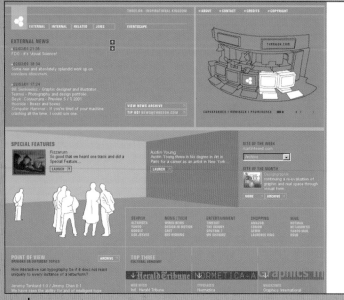

Most sites are planned and constructed using a grid system, which defines the layout of static elements like navigational elements, headers and footers etc., and the space where content and graphics will go on each page.

These grids can then be made into site-wide design templates, making updating easy and giving the site a consistent look. Most sites don't just rely on the one template, though: expect to have to knock out several different versions to accommodate different sections of the site.

Make sure the templates can adequately display the intended content - don't be surprised if several pages end up needing a non-standard design.

Some web-authoring tools like Dreamweaver allow you to 'lock out' certain parts of the page, this is a handy way of preventing 'experimental' team workers from trashing the foundation HTML.

Grids and templates

Find out the latest developments in web design on this site.

www.threeoh.com

BRANDING THE SITE

In traditional media, companies try to express their brand values and aspirations in their logo and typeface, often producing complex, literal interpretations. On the web, elaborate logos rarely work and invariably hog far too much screen real estate. Simple and concise logos offer a more flexible solution, easily scaled for different uses, like banners and small graphic links. Let the content and functionality of the website articulate your values and aspirations, not a thumping great logo.

↗ **www.webreference.com/new/branding.html**

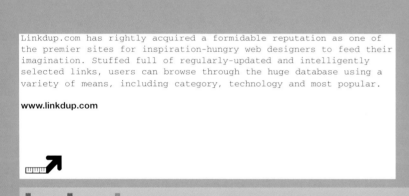

Linkdup.com has rightly acquired a formidable reputation as one of the premier sites for inspiration-hungry web designers to feed their imagination. Stuffed full of regularly-updated and intelligently selected links, users can browse through the huge database using a variety of means, including category, technology and most popular.

www.linkdup.com

↗

 The colours that can be displayed on PCs and Macs running Netscape and IE on a 256 colour display are known as the web-safe palette.

Cross-platform issues reduce this palette to just 216 colours. Using colours outside this palette can result in undesirable 'dithered' effects, where colours are crudely mixed together to give the impression of another colour.

In HTML, colours are expressed as either hexadecimal values (e.g. #FF0000) or as colour names (e.g. red). As there are only a limited amount of named colours it's best to use hex codes. Although these look complicated at first, they're quite logical: your monitor mixes red, green and blue to create what you see onscreen: in hex code, FF stands for 'full' and 00 for 'off', so a background colour of #FF0000 translates into 'full red, no green and no blue' - giving you red. #0000FF would be blue and #00FF00 green.

Resources:

www.lynda.com/hex.html,
www.builder.com/Graphics/CTips/ss01.html
www.html-color-codes.com

The web-safe palette

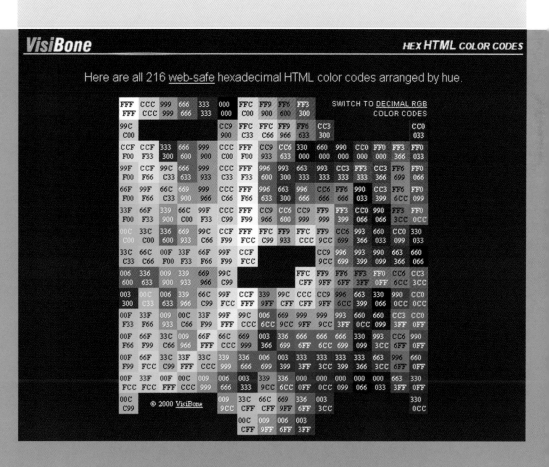

USING OUTSIDE DESIGNERS

If your own efforts are proving horribly inadequate, it's time to employ a web-design company or freelancer, but be careful:

👍 It's not unheard of for design companies to wheel in their hot-shot designers when pitching for a contract, only for the client to find a completely different set of faces across the table once the deal's signed. Specify who you want to work with on the project if it's their skill and style you're after.

👍 If you like a design company's portfolio, find out who actually created the work – web design agencies have been known to promote themselves on the work of long since departed employees. Check the site with a validator and in various browsers to make sure it looks great for all users and not just on their laptop.

Don't go to agencies expecting them to author something similar to the supercool interactive site you've just seen at an awards ceremony. A good design team will suggest the most appropriate style for your website, not the one with the most gizmos. Let them get on with their job – they're the designers not you!

Conversely, some of the bigger agencies can coerce smaller clients into letting them produce sites that'll look great in their design portfolio but not actually fulfil the brief of the site. Keep a firm grasp of the site's objectives and don't get side-tracked with design fluff.

Freelancers may often offer better value and faster lines of communication, but make sure they've got the resources to fulfil their deadlines. If they're any good they'll be busy, tie them down to a set number of days per week on your project, if need be.

This hugely entertaining site comes complete with a browser-stretching interface and unorthodox navigation, where the links are seen as houses in a street. Authored with a mix of HTML and Flash, the page is full of surprises and hidden interactive elements.

www.ndroid.com

WEB-SAFE FONTS:

There is no such thing as 'web-safe' fonts – so if the user hasn't got that obscure 'phat' font you've specified in your code they'll just get their default font instead. You can, however, use combinations of fonts like 'Arial, Helvetica, Verdana, sans-serif' and 'Times New Roman, Times, serif' which would produce sans-serif and serif fonts respectively on the majority of users' machines.

Newer browsers let you 'embed' fonts on a web page, but this technology is still in its infancy and at the whim of the usual Netscape / IE incompatibilities. Despite its undoubted appeal, the reality is that until font embedding enjoys widespread browser support, it's simply not worth the hassle.

Netscape's solution is called Dynamic Fonts, based on TrueDoc technology ➚**www.truedoc.com** and Microsoft's [PC] is called Open Type ➚ **www.microsoft.com/typography**

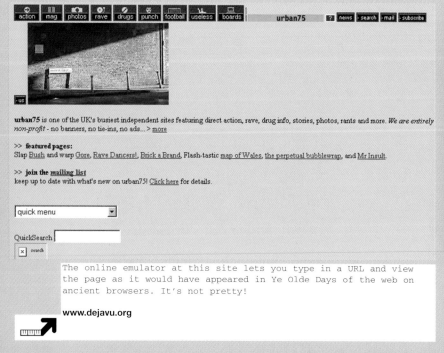

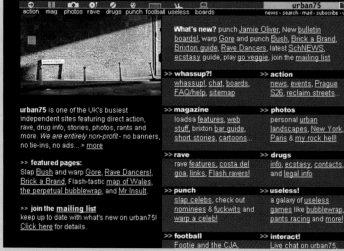

The online emulator at this site lets you type in a URL and view the page as it would have appeared in Ye Olde Days of the web on ancient browsers. It's not pretty!

www.dejavu.org

➚

HOW WIDE SHOULD MY SITE BE?

Because you've no way of knowing what screen will be used to view your site – and it could be anything from a 60-inch plasma monster to a tiny PDA screen – trying to produce a site that looks good on all browsers and at all resolutions is impossible. Even on the same size monitor, your site may look totally different depending on the O/S, the browser and even the personal preferences of the user, who may choose to override your arty little font with a whopping great Times New Roman.

Faced with this dilemma, some designers have forced larger resolutions on users, posting up 'site best seen at 1024 x 768 inch' notices on their home pages. It is not for the designer to decide how wide a user's screen should be and building to higher resolutions may render a site unusable on smaller screens.

One more flexible solution is to use relative screen sizes that shrink and expand to fill the screen using the **<TABLE WIDTH="100%">** tag. This can work well and partly solves the problems of displaying at multiple resolutions. However, it can go horribly wrong on larger screens where text ends up stretching for miles across a page.

Many designers have compromised by introducing a fixed width of 580 to 610 pixels, which is at least readable on the majority of browsers, but not WebTV (544 x 372 pixels) or AOL-TV (585 x 386 pixels), this squishes pages to fit, typically with ugly results.

↗ CHECK HOW YOUR PAGES WILL LOOK AT DIFFERENT RESOLUTIONS:

Browser sizer: **www.applythis.com/browsersizer/**
BrowserMaster: **www.applythis.com/browsermaster/**
Browserola Emulator: **www.codo.com/browserola/**
WebTV emulator:
http://developer.webtv.net/design/tools/viewer
AOL-TV style guide:
http://webinfo.aol.com/support/TVStyle104.doc

↗ BROWSER USAGE/COMPATIBILITY RESOURCES:

http://webdesign.about.com/compute/webdesign/msubb
rowsercomp.htm
www.upsdell.com/BrowserNews/stat.htm

HOW TO MAKE WEB PAGES PRINTER-FRIENDLY

Onscreen text generally needs to be a larger size than on paper, sans-serif fonts are easier to read on screen, but serif fonts are easier to read on paper – so how can you optimise your pages for both mediums?

Happily, the CCS2 specification supports 'media types' which lets you specify different stylesheet settings for screen, print, hand-helds, speech browsers and more. Unhappily, only the newest browsers support it. For now, the best compromise is to produce HTML and PDF versions of your document.

PDFs can be inserted into a web page by using **<EMBED SRC="myfile.pdf">** or **<OBJECT>** tags, or by linking to them using the ** tag**. If the file is large, warn people first by adding the file size to the link, e.g. '**My book – download PDF version (122k)**'. To give your site visitors the best of both worlds, you can include a piece of code that will automatically send the print-optimised version to the printer: put this in the **<HEAD>** part of your HTML document (include a HTML text link to the PDF file for older browsers):

<LINK REL="alternative" MEDIA="print" HREF="myfile.pdf" TYPE="application/postscript">

Specify one-inch margins and a printable area of 15.9cm wide by 22.9cm tall to accommodate the two most common international page formats (A4 and US Letter)

Use the script at **http://wsabstract.com/howto/newtech2.shtml** to include a custom 'print this page' graphic on your site.

PDF TIPS:
www.pdfzone.com/

CSS2 MEDIA TYPES:
www.w3schools.com/css/css_mediatypes.asp

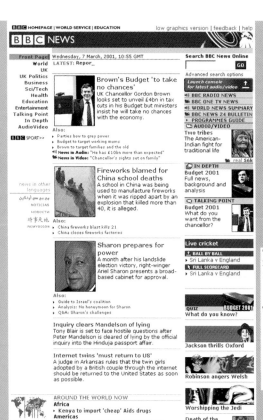

The BBC website is widely regarded as one of the finest on the net. Rich in content, fast to download and with no pointless frills, this is a great example of how information should be presented online. A 'low graphics' version ensures maximum accessibility.

www.bbc.co.uk

THE HOME PAGE

Think of a child's attention span and you're close to knowing the patience of the average surfer. They don't want to fiddle about with splash screens, weird navigations and thumping great animations – they want their content NOW!

Make it blindingly obvious what the site's about and what users can expect to find and do there. Make sure the site can deliver on any claims or promises – don't call it an 'interactive information portal for the gaming generation' if all you've got is a page full of links. The home page should quickly establish the branding of the site along with all the major categories of interest, including a flexible area to flag up any new stories or promotions to regular visitors. Don't overwhelm users with choices and keep all text short and to the point. Consider updating elements of the home page regularly so users can see the site's still alive.

All key information and category links should appear in the first 'screen-full' so that users don't have to scroll down to find what's on offer. It's also a good place to put in a site-wide search box. Ensure that all graphics have ALT text attributes – try turning off your browser's images and seeing how your page might look on a slow connection: is it navigable?

Graphics should be fastidiously optimised and restraint shown when deciding colour schemes: less is most definitely more in most cases.

Some sites inflict 'splash screens' on users (short entry pages before the main home page, like the titles before a film). These can contain animations, information about the site or instructions about the technology needed to view it. Although some add value and interest, mostly they're inappropriate and annoying, and many people will leave the site long before the animation has even finished.

The home page should be fast to load and not demand any obscure plug-ins or blast out music unannounced – some people might be surfing from work and wouldn't appreciate your boss-alerting rendition of 'Anarchy in the UK'.

Insisting that users adjust the colour depth and resolution of their monitor or that they download the very latest browser is another way to send them fleeing. If users absolutely must download software to interact with your site, provide an alternative HTML page to provide more information of what's in store.

Some sites use JavaScript to find out the size of a user's screen and then fill the whole thing with their page. Don't. It's very, very annoying and the equivalent of being invited into a stranger's home and taking over their entire sofa. Multiple pop-up windows are equally irritating and most people will assume they're just adverts and ignore or close them without even looking.

SEE SOME BAD HOME PAGES:
http://webpagesthatsuck.com
www.forkinthehead.com
http://webworst.about.com

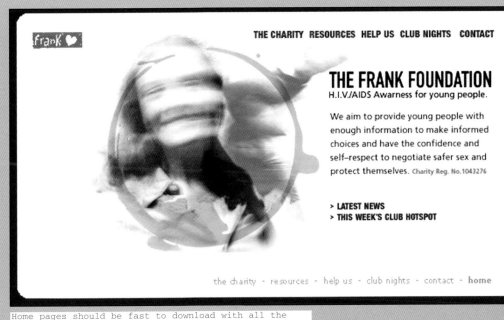

Home pages should be fast to download with all the main options available without scrolling.

 www.frankfoundation.org.uk/

TO FLASH OR NOT TO FLASH?

There's no denying that Flash represents a major step forward in making the web a more dynamic and graphically-rich place, but it's not a 'one size fits all solution'. There are many instances where Flash is not appropriate and insisting on its use would seriously impact on the usability and functionality of a site.

TASK-BASED SITES

Flash is a time-based medium, the web is not. Anything that utilises animation to 'enhance' the delivery of content will increase the time it takes the user to complete a task, which makes Flash inappropriate for most task-based sites, e.g. those that are shopping, information and search-based.

The web is not linear, Flash is. Web navigation is based on hyperlinks and the back button, whereas Flash navigation is based on sequences with entry points and exit points. So if someone sees a great product on a non-Flash site they could spread the word by posting up the URL for others to see, ('Hey, check out **www.fab-gizmos.com/products.cgi?gizmo_id=333**').

However, if the entire site is in Flash, things get a little more long-winded, 'Go to **www.fab-gizmos.com** (make sure you've got the latest Flash plug in first), click on 'skip intro', wait for the interactive navigational graphics to load, click on 'our products', go to 'gizmos', select 'latest widgets' from the fold-out animated menu and then it's the third on the list.'

ACCESSIBILITY

Flash is intrinsically inaccessible to anyone who cannot see properly and is very often inaccessible to deaf or hard-of-hearing users who rely on text-to-speech browsers – make sure your site offers text alternatives.

SEARCH ENGINES

For an e-commerce site, exclusively using Flash could lead to disastrous results, as most search engines simply won't index all the content of the site, if any. Although search engines are being developed specifically to index Flash files there are doubts as to how accurate the information returned may be (a way round this is to create what's known as 'doorway' pages, explained later).

⬈ RESOURCES
'The Invisible Web: Where Search Engines Fear to Go'
www.powerhomebiz.com/vol25/invisible.htm

⬈ CHALLENGING ARTICLE BY JAKOB NIELSEN 'FLASH 99% BAD':
www.useit.com/alertbox/20001029.html

This is a Japanese/English site that uses Flash animations with sound to create a fun interactive site that should keep kids amused for, well at least ten minutes.

⬈ **www.youchan.com**

ToyBox top ↑

ToyBox top ↑

I'd come to philips.com looking for information on a cordless phone, not for a multimedia extravaganza. All manner of navigational elements compete with each other to make this a real dog's dinner of an interface – menus slide across the page, graphics blink, icons animate and usability comes a poor last. It didn't get any better inside. Horrible.

www.philips.com

Sure, this experimental Flash interface looks original and the grid on the right animates in a really 'clever' way. Trouble was, I couldn't work out what it was supposed to do, and after three minutes of pointlessly dragging things around, I left the site.

www.unstablemedia.com/

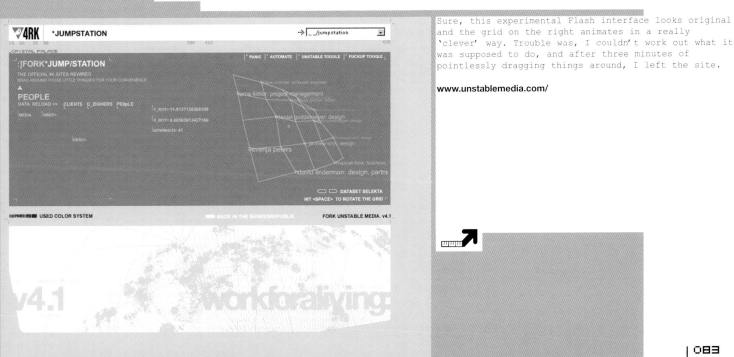

Created to provide a rapidly updated 'designers'
playground', **k10k.net** aim to showcase 'all the crazy
ideas that a client would never buy'.

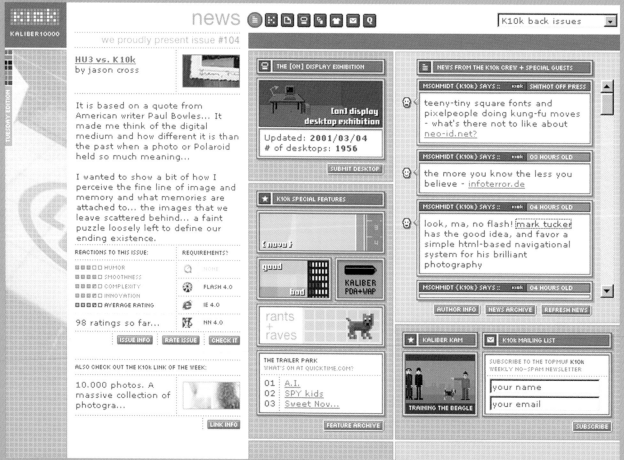

LONG BOOKMARKED BY ASPIRING AND ESTABLISHED WEB DESIGNERS ALIKE, THIS 'DESIGNER'S LUNCHBOX' IS AN ESSENTIAL RESOURCE FOR INSPIRATION, NEWS AND TREND-SPOTTING. AT TIMES IT CAN BE A LITTLE HIT AND MISS, BUT THAT'S PART OF THE FUN! MICHAEL SCHMIDT EXPLAINS:

WHAT ARE THE AIMS OF THE SITE?

K10k strives to inspire, to provoke, to allow both others and ourselves the joy of having full creative freedom – to give people a break, and re-charge their batteries. We want to put the focus on design, on the whole visual experience, and show everyone out there that not everything has to be streamlined, menu-to-the-left, make-it-look-like-Amazon.

HOW'S IT FUNDED?

It's completely non-profit. We do have a couple of sponsors on board to help us with the operating costs, but apart from that there's no money coming in from the site at all and we haven't found a way of introducing crazy dollars to the K10k machinery that seems fit. And we think it is best if we keep clear of ugly banners and other dodgy deals.

WHAT'S YOUR OPINION ON: A) LATEST TECHNOLOGY OR MAXIMUM COMPATIBILITY WITH DIFFERENT/OLDER BROWSERS?

Nothing is more annoying than going to a site and getting hit with an error message stating that you need to use another browser to access it – that's a personal decision, something which the site creator shouldn't try to choose for you.

However, at some point in time you'll need to cut some strings if you want to take full advantage of the features of modern browsers – many of which can be used for the kind of funk that is happening on K10k, and which are crucial to play with to keep up with where internet technology is going.

B) COMMERCIALISATION OF THE WEB, UNAVOIDABLE?

It's completely unavoidable – just as TV, music, literature, and practically all the other forms of media out there have been completely commercialised, so has the idealistic notion of the internet as the great free communication tool been sucked in, chewed up and spat out again by all the people who just want to make a fast buck.

Nowadays most corporate sites have banners (case in point: Macromedia.com – what the hell are they thinking?), everybody wants your email address (even though they, of course, won't sell it).

But, hey, that's the way it is, no point in complaining about it. Thankfully, the concept of personal publishing is thriving on the net, with millions of non-commercial sites devoted to any topic you can think of.

THE FUTURE OF THE WEB, WHERE'S IT HEADING?

Hopefully towards some sort of standardisation when it comes to browsers and the whole 'surfing' experience.

ANY TIPS TO DESIGNERS STARTING OUT ON THE WEB?

Please try to think real hard about the site, before you start working on it – come up with an idea that's (semi) brilliant, and you'll find that the actual work part becomes so much easier. Try not to bite off more than you can chew – we've seen a lot of sites wither and die, because the people responsible for them decided to take the site in too many directions at the same time. Often the simplest ideas are the greatest. Remember: something that is great and ugly is always more interesting than something beautiful and boring.

05
FILE STRUCTURE AND NAVIGATION

You may well like your desk as a complete mess with papers all over the place, but when it comes to the web, you're going to have to sharpen up your act. If you want any hope of keeping control over your site, you're going to have learn the correct conventions and keep it organised!

WHAT'S A URL?

URL stands for Uniform Resource Locator and every file on the web has a unique one (i.e. an address) containing information about where it is and what a browser should do with it. When you type in a URL, the browser issues a **GET [/myfiles]/ HTTP/1.0** (or **1.1**) instruction to the server, which is configured to return the requested files.

The anatomy of a URL is as follows:

http://www.max-hits.net/myfiles/file.html
protocol server name directory file name

The protocol tells the browser how to deal with the file. In this example '**http**' (hypertext transfer protocol) means that it's a web page. Other schemes include FTP (file transfer protocol), HTTPS (secure web pages), News (for sending to and reading Usenet newsgroups), Mailto (for sending mail), Gopher (for searching for info) and File (for files on a local hard disk). Schemes are always typed in lowercase. The server name contains information about where the server is located, while the directory points to where the file is located, followed by the file name itself.

A URL that doesn't specify a file name but just has a forward slash on the end e.g., **www.max-hits.net/myfiles/** will tell the browser to look for the default file in the last directory named (i.e. 'myfiles' directory). '**index.html**' and '**default.htm**' are common default names.

FILE NAMES

Craig Robinson has dedicated an entire site to pixel art, reducing well-known personalities, works of art and everyday scenes down to their smallest possible size.

Using static and animated GIFs, this deceptively simple, low-tech site has earned rave reviews and attracted a healthy hit rate.

Put together on a non-profit basis, Craig describes how he finances the site, 'Well, it doesn't really cost me anything as the site's hosted for free. It has always been a hobby, and any other costs incurred are done in the spirit of it being a hobby. If I was into train sets, I'd have to buy miniature trees; with FFF it's mainly obscene phone bills.'

www.flipflopflyin.com

One of the most common reasons for people getting 'file not found' errors or seeing graphics missing from their web pages is because they've either linked to them incorrectly, or mixed up the case of the file name. If you've made a reference to **image.gif** in your HTML document but named the actual file **Image.GIF**' some browsers won't find the image. The same applies for URLs, so it's important to keep them consistent:

www.max-hits.net/Myfiles/File.html

isn't the same as:

www.max-hits.net/myfiles/file.html

My advice is to keep all file names lowercase, all the time.

Never leave spaces in file names, use underscores instead (e.g. '**five_beers_tonight.html**')

SUB-FOLDERS

For larger sites, it makes sense to put related files into
sub-folders, otherwise you'll end up with a directory
bursting at the seams with hundreds of files. The most
common practice is to put all the graphics together into a
sub-folder called **images**. Larger sites may have multiple
sub-directories for HTML documents, some with their own
image folders. Using sub-folders helps keep the site
manageable and makes it easy to see how much
content each section has.

www.kraftwerk.de

www.sissyfight.com

www.numerozine.com/

RELATIVE VS. ABSOLUTE PATHS

You can specify paths to files in two different ways: a relative URL describes the path to a file in relation to itself, so a path to an image in the same folder as the HTML file would be ****. If the file was inside a sub-folder called **images**, the path would be ****.

An absolute path specifies the entire location of a file: scheme, server name, directory and filename – the lot – and might look like:

WHY TYPE ALL THAT STUFF IN?

Using relative links ties you down to your current directory structure – if you move a folder later you'll have to change all your links to and from that page. Using absolute links guarantees that the page will always find the files it refers to, no matter where the page is moved to.

SO WHY NOT USE THEM ALL THE TIME?

All those extra long URLs can soon start adding weight to the HTML document, and you have to be online for your pages to display. Unless you have a permanent connection, using relative URLs makes it easier to build the site at your own pace, check the links locally and upload the files later.

Be careful not to refer to images on your hard drive instead of your webspace – it's a very common mistake! Some web-authoring programs will put in paths like **file:C:\path\file.html** – change these to relative URLs (e.g., **file.html**) or absolute URLs (e.g., **http://server/path/file.html**). Don't use we!rd ch@r@cters or spaces (*, @, %, $, !, ¬, etc...) either.

◥ A BEGINNER'S GUIDE TO URLS
www.ncsa.uiuc.edu/demoweb/url-primer.html

www.city.popwire.com

www.urban75.com/Mag/brand.html

www.tate.org

ABSOLUTE

DESIGNING NAVIGATION

Navigation should be clear, self-explanatory and consistent. The main site categories should appear in the same place on every page and appear high enough on the page to avoid the need to scroll. Don't overdo it and overwhelm the user with links. Be selective!

Go for the simplest, most accessible solution whenever possible and don't use 'funky' Java applets or complex Flash/Javascript rollovers as the sole means of accessing pages – not all browsers will be able to see the links. If your navigation bar is entirely made up of graphics, include a text-only version and make sure that each graphic has clear and self-explanatory 'ALT' text information provided.

Sites that use stylised concepts or metaphors as their primary navigation often end up baffling users, and having a site full of weird icons, endless clicks, dead ends and irrelevant spinning gizmos guarantees visitors won't return.

Try to make all pages accessible in less than three clicks (four or five is acceptable for very large sites) and most of all, keep it simple.

Encourage users to explore different parts of the site by suggesting pages of related interest or, if appropriate, works by the same author. Don't just slap in the obvious links, but add links to more obscure pages that may interest users, add value to the site and, best of all, keep the user there.

'Breadcrumb' trails can be a useful navigational aid. These take the form of HTML links showing the route from the home page to the current page:

e.g. **>home >products >widgets**

www.tate.org

BUILDING NAVIGATION

Setting up a site's navigation system can be time-consuming at first, but by using a series of templates – each one listing all the main components of the site with changing secondary menus for sub-sections – subsequent updates should be easy.

If you wish to add or change the navigation bars on an existing site, many authoring programs allow you to globally search and replace the HTML on every page or selected pages. So you could, for instance, build your new navigation in a table and have the programs automatically slap it on the top of every page.

To let people know what section they're in, highlight the link or icon for that section in the navigation bar.

Don't annoy users by retaining live links to the page they're already on: i.e. if they're on the 'partners' home page, take out the live link for that section in the navigation bar.

Once you've built your navigation, don't forget to test it extensively.

 # TOP TEN NAVIGATION DESIGN TIPS:

01. If you're using an icon-based navigation, make sure it's easily understandable and, preferably, has a text explanation underneath

02. All site categories should have clear, straightforward titles – avoid ambiguous wording and make sure the text is set against a contrasting background

03. If you have to include ghastly advertising banners, try to reduce their impact by incorporating them into the navigation bar

04. Include the branding/logo of the site in the navigation bar and use it as a link back to the site's home page

05. Set 'outsiders' some tasks, like finding certain pages or ordering goods, and note any difficulties they encounter

06. Users should be able to go through the site without having to use the browser 'back' button – try it out!

07. Unless you're planning your page as a portal, don't stick external links off the front page of your site. If the links point to more interesting content than what's on offer, your visitor will quite probably use them

08. Keep your navigation in a separate HTML table as it'll display faster that way

09. Use context-sensitive 'help' links where needed. If you've a complicated sign-in procedure, put links to explanatory pages next to items where users may get confused

10. If you want to encourage user feedback, litter the site with 'call to action' buttons in appropriate articles, linking to feedback forms and bulletin boards

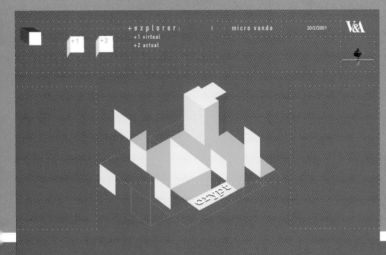

The Victoria and Albert Museum

Cromwell Road, London SW7 2RL
Telephone 020 7 942 2000

Situated on the corner of Cromwell Road and Exhibition
Road, the Victoria and Albert Museum is within a few
minutes walk from South Kensington Underground Station.

Transport

Tube: South Kensington (Piccadilly, District and Circle Lines)
Buses: No. 14 and No. 74

For any further information that you may require, please
call our main desk between the hours 10am and 5.45pm.

The front page immediately perplexes visitors with a
set of spinning cubes, animated icons and graphic links
that give no clue as to where they lead. There's no
descriptive text of what's on offer, only vague titles
(what does 'give and take' and 'the spiral' mean?) and
with no 'ALT' text to be found anywhere, the only
option is to click away and hope for the best...

Clicking on the third box takes you to a page that
doesn't trouble itself with an introduction or
explanation, instead serving up another set of
indecipherable cubes. The page is captioned 'micro
vanda', although no explanation is offered as to what
it means. The red and orange 3D cubes do nothing.

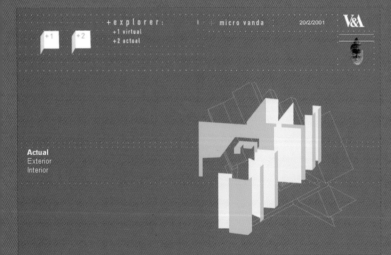

Actual
Exterior
Interior

Spotlight

Another visually troubled page offering precious little
content, virtually no navigation, no logical path and
absolutely nothing in the way of a help file to guide
(understandably) confused visitors.

Another click and another empty page offering just two
baffling new links, 'exterior' and 'interior'.
Needless to say, the big blue shape in the middle and
the double triangle shape on the left don't actually
do anything.

'FLASHTURBATION': THE UNNECESSARY USE OF FLASH TO GRATIFY THE DESIGNER'S EGO AND SERVE UP A LOAD OF EYE CANDY, INAPPROPRIATE TO THE SITE'S KEY PURPOSE.

For a public site describing itself as a 'National research library and primary source archive for the history of art and design' you'd reasonably expect usability and accessibility issues to be at the fore, with clear navigation guiding users to the resources on offer.

Unfortunately, the designers seem to have thought differently, producing a celebration of style over, well, everything else. Naturally, users have no say on how they'd like to view the site, with an automatic browser detection script forcing you to use Flash with no means for users to choose a HTML version.

The front page immediately perplexes visitors with a set of spinning cubes, animated icons and graphic links that offer no clue as to where they lead. There's no descriptive text of what's on offer, only vague titles (what does 'give and take' mean?) and with no 'ALT' text to be found anywhere, the only option is to click away and hope for the best.

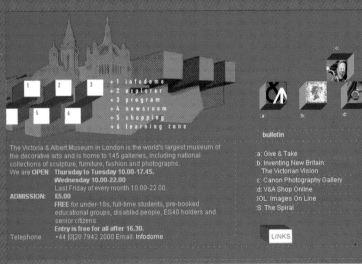

Content at last! Clicking on the 'exterior' link has taken me to an interactive map. Only after persevering with this map does it becomes apparent that you can access the entire collection by clicking on the buildings, although most people would have long given up by now. Quite why they couldn't have put a text link on the front page saying, 'interactive map of museum and area' is anyone's guess. Or, even better, built a site that was accessible to all, fast to download, easy to navigate and able to deliver the content to users in an appropriate manner.

There's only one thing worse than a badly designed site and that's a badly-designed site that doesn't work.

06

CREATING WEB GRAPHICS

Web image files can be categorised into two kinds, Bitmap-based (.jpg .gif etc.) and Vector-based (flash, .svg etc.). Bitmap-based files are made up of individually-coloured squares called pixels and are commonly used for photo-realistic images that require complex colour variations. Vector graphics are made up of mathematical lines and curves and are generally used for illustrations, text and flat artwork. Traditionally, you'd need separate programs for working with vector and bitmap files, but recent versions of programs like Macromedia Fireworks, Adobe Photoshop and Xara X let you work in both formats.

SETTING UP YOUR GRAPHICS PROGRAM FOR WEB WORK:

> Work in RGB colour mode – don't use CYMK

> Work with the rulers visible onscreen, making sure they're set to 'pixels' (not 'inches' or 'points' etc.) and use guides to keep your work aligned

> Set the resolution of your image to 72 pixels/inch (a.k.a. 'dpi'), which is the resolution of the majority of users' screens

> Because a browser's tool and scroll bars eat into the real estate available on screen, you have to fit your design into a smaller window than the maximum screen resolution

↗ VECTOR VS. BITMAP

http://graphicdesign.about.com/arts/graphicdesign/library/weekly/aa042398.h

TO ADDRESS THIS RESOLUTION	USE THESE DIMENSIONS
640w x 480h	600w x 300h
800w x 600h	760w x 420h
1024w x 768h	955w x 600h

KEEP 'EM SMALL!

The key to putting up images on the web is optimisation. It's vital to crush the little blighters down to within an inch of their lives as hefty, bloated images equal unhappy surfers.

Although some folk are lucky enough to enjoy high speed web access, there are many still stuck with creaking 14.4k and 28.8k modems – and don't forget those on the road accessing through laptops and slow data cell-phone connections.

People don't like waiting for downloads, so work on the assumption they'll start to twitch after a ten-second wait – giving you an upper limit of an 18k page size for 14.4 modems and 35k for 28.8. Not much, huh?

Keeping the load time of your pages down is critical. The larger the file, the longer the user waits for it to appear – and the more likely they are to leave. Huge, unnecessary graphics are a definite trademark of an amateur site – so be sparing!

Try to reuse graphics throughout your site, and bear in mind that if your ISP has bandwidth restrictions, big files will put you through their limit quicker. Consider what the user will see as the page downloads: a slowly unfurling, page-filling graphic will have fingers hovering over the 'back' button – try using smaller graphics that will at least give the impression of something happening. If you really need a hefty graphic on your site, warn people before they click on the link to it, e.g. ****My whopping great photo **(98k)**

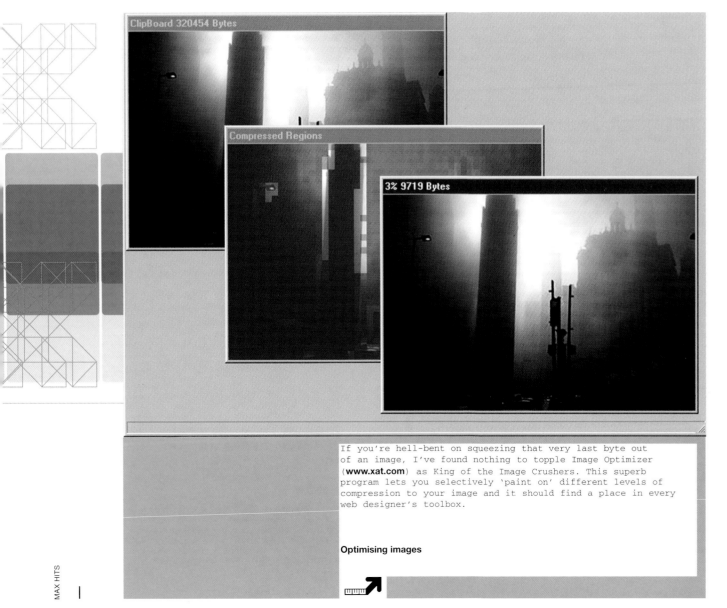

If you're hell-bent on squeezing that very last byte out of an image, I've found nothing to topple Image Optimizer (**www.xat.com**) as King of the Image Crushers. This superb program lets you selectively 'paint on' different levels of compression to your image and it should find a place in every web designer's toolbox.

Optimising images

WHAT GRAPHICS FORMAT?

The most common formats on the web are GIF and JPG, although newer formats are slowly beginning to rival their dominance. Both use compression to reduce file size, so only save in these formats when you've finished editing your graphic and always keep a non-compressed back-up of the original file.

.JPEG (Joint Photographic Expert Group)
.jpg/.jpeg, bitmap, colour depth: up to 24 bit

Best used for photos, JPEGs let you set your own compression level, so experiment to find an acceptable compromise between image quality and file size. 'Progressive' JPEGs give the illusion of downloading quicker by displaying a low-quality version first, which is refined in subsequent 'passes', however, this format is not as widely supported.

👍 Blurring a JPEG image slightly can result in substantial file size savings.

GIF 97a/89a (Graphical image format)
.gif, bitmap, colour depth: up to 8 bit

GIF files can only support a maximum of 256 colours and work best on flat colour artwork. The colour limitations can wreak havoc on photographs, reducing a graduated sky to unnatural bands of colour. However, photos that only contain a few hues can be compressed very successfully with the added bonus of transparency support – so you can make your images 'float'' on the page background. Although slightly larger in size, interlaced GIFs can give the impression of appearing faster by downloading in several 'passes', as the image is shown to sharpen during download.

👍 Untick the 'anti-aliasing' option when saving small graphics – it creates extra colours and can make the text look 'fuzzy'.

GIFs can also be animated, with most of the popular graphic editors offering frame-by-frame adjustment, tweening and looping options.

👍 Not everyone will get to see the end of your animation, so repeat the key message and/or branding in the start frame.

Doodle Castle
by webRat

PNG (Portable Network Graphics)
.png, bitmap, colour depth: up to 32 bit

PNGs offer better compression rates than both GIFs and
JPEGs, with support for interlacing, transparency, alpha
channels and 32 bit colour, but because of Netscape
and Microsoft's reluctance to adopt the format quickly,
not everyone's browser will be able to read them. Use
with caution.

FLASHPIX
.fpx, bitmap

Developed by Kodak, FlashPix can create multi-resolution,
zoomable, scrollable, bitmap images with metadata and
embedded audio. A plug-in has to be downloaded to view
the images in a browser (more info: **www.flashpix.com**).

SWF (Flash)
.swf, vector

Designed by Macromedia specifically for delivering fast
graphics and animation over the web, SWF files support
anti-aliasing, interaction and media streaming. Now widely
supported by the vast majority of browsers.

Jens-Uwe Grau pushes back the boundaries of Flash Action Scripting
with this ingenious shape-building tool, which lets you drag and drop
elements from a 'black box' to build your own construction. You can
even stick lights on it when you're finished! Community interaction is
encouraged, with online galleries and the ability to forward your
masterpiece to friends.

www.distorter.net

COMING UP!

Although these proposed file formats offer considerable advantages over the current formats, it's unlikely that they will enjoy widespread support for many years.

SVG (Scaleable Vector Graphics)
.svg, vector

Entirely based on XML, SVG is an emerging vector format offering fast downloads, high-resolution graphics and zooming, where users can zoom into images for extra detail. Since it is entirely text-based, search engines can index SVG images, allowing users to search for text within images, like the names of streets on maps. SVG also supports style sheets, high-resolution printing, compact file sizes and dynamic content, animation, and interactivity through scripting. Although not yet widely supported, this format is expected to grow in popularity.

JPEG2000:
bitmap, colour depth: 24 bit

Offering smaller file sizes than JPEGs and able to stream down at different resolutions, JPEG2000 will allow designers to control how much resolution they want to make available for download and users can decide how much of that resolution they want. Major drawback: no transparency support.

MNG (Multiple-image Network Graphics)
.mng/.jng, bitmap, colour depth: up to 24 bit

Offers an animated version of the PNG format with transparency and vastly improved compression over GIFs.

RESOURCES:

➔ **GRAPHICS ON THE WEB:**
www.w3.org/Graphics/
www.w3.org/Graphics/Activity
www.designer-
info.com/Writing/web_graphics_tutorial.htm

➔ **OPTIMISING WEB GRAPHICS:**
www.webreference.com/dev/graphics/
www.netmechanic.com/accelerate.htm
www.jpegwizard.com
www.spinwave.com

➔ **AUTHORING SVG:**
http://graphicssoft.about.com/msubsvgauth.htm

GREYSCALE WRISTCAM PHOTOG

FAMEWHORE

GREYSCALE WRISTCAM PHOTOGRAPHY

FAMEWHORE

This one-page site uses Flash to display a selection of photographs taken on a wristcam. Placing your mouse over an image lets you select from a series of images.

www.famewhore.com

MULTIMEDIA AND INTERACTION

To many, their first surf around the web is a big disappointment. Where's the full-screen video streaming down in real time like they see in the movies? Where's the super-fast, quick-loading interactive games and audio visual multimedia feasts complete with CD quality sound? Instead, disgruntled users have to put up with a squinty little video window with jerky heads talking out of synch or nod off to sleep as movies saunter down the line v-e-r-y slowly.

The problem with multimedia has always been the same: bandwidth. It eats up loads of the stuff. It's like a hugely overweight bloke trying to squeeze into a Mini motor car: he might get in there eventually, but boy, it's going to be a painful experience.

It is getting better. Connection speeds are slowly rising and improvements in compression technologies bring the promise of full-screen web video just a little closer each year.

Good multimedia can bring in traffic galore, generate worldwide publicity and set you off on the path to your first web million. Bad multimedia can irritate and annoy users to the point that they'll never return to your site.

It's all about appropriate use and not just throwing in gizmos and gadgets for the sake of it – have you ever found yourself reading an interesting newspaper article and wishing that there were some pointless spinning things whirring on the corner of the page?

Just because something moves, wiggles, warbles or squeaks, it doesn't make it inherently interesting, and such effects should only be used where relevant and where they add value to the user experience.

Coded by hand with a simple text editor, Brent Gustafson's inspirational site features a series of simple HTML/DHTML experiments.

Boxes fly around, cubes bounce down the screen and all manner of useless but amusing distractions keep you from doing some meaningful work.

www.assembler.org

Possibly the worst kind of animation is the **<BLINK>** tag which, as the name suggests, causes text to flash on and off. Don't use it: it looks rubbish, irritates people and can provoke seizures in epilepsy sufferers.

DHTML offers considerable scope for animating text, and advanced editors like Dreamweaver simplify the process with a timeline interface. Before you spend hours building your animating masterpiece, however, don't forget that they don't always display as intended over the web, with users often suffering slow and jerking transitions. As ever, test thoroughly first.

The death of the animated GIF has been exaggerated. Despite the onslaught of faster and more versatile technologies like Flash, the web is still festooned with the all-blinking, all-spinning things, often employed for banner ads. Use sparingly!

Now firmly established as the most popular web vector animation format, Flash supports tweening (automatic creation of animated frames between two points), streaming and scripting (often augmented with JavaScript). As the

program gains more power with each release, so does its complexity, although beginners should have no trouble knocking out simple animations.

Shockwave is a technology developed by Macromedia that enables Web pages to include multimedia objects. Shockwave files are authored in Macromedia Director and compressed for the web using a program called Afterburner. The program supports audio, animation, video, scripting and interaction. Users will need the Shockwave plug-in to view files.

Several software packages let you build interactive panoramas, which users can scroll and zoom around. Although some of these can be quite heavy, they can add real interest and value to a page. Popular panorama programs include QuickTime QTVR [MAC]
↗ **www.apple.com** and MGI PhotoVista [PC]
↗ **www.mgisoft.com**.

👍 Always include text links to specific software plug-ins needed to view your site (e.g. Acrobat Reader, Shockwave).

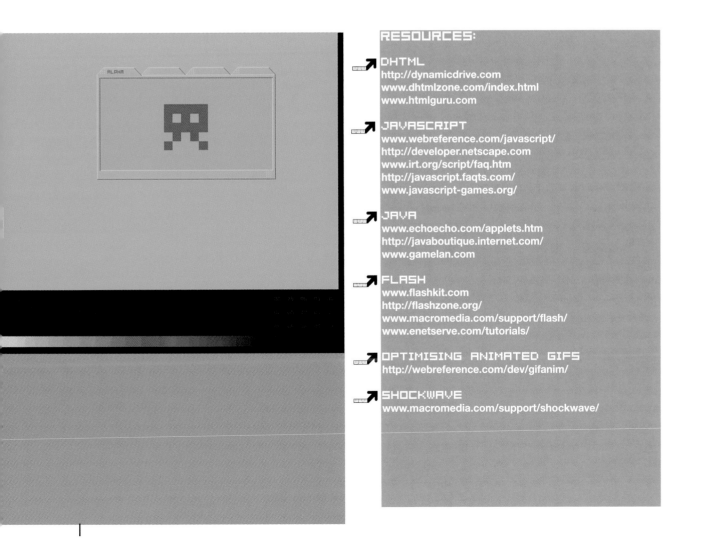

RESOURCES:

↗ **DHTML**
http://dynamicdrive.com
www.dhtmlzone.com/index.html
www.htmlguru.com

↗ **JAVASCRIPT**
www.webreference.com/javascript/
http://developer.netscape.com
www.irt.org/script/faq.htm
http://javascript.faqts.com/
www.javascript-games.org/

↗ **JAVA**
www.echoecho.com/applets.htm
http://javaboutique.internet.com/
www.gamelan.com

↗ **FLASH**
www.flashkit.com
http://flashzone.org/
www.macromedia.com/support/flash/
www.enetserve.com/tutorials/

↗ **OPTIMISING ANIMATED GIFS**
http://webreference.com/dev/gifanim/

↗ **SHOCKWAVE**
www.macromedia.com/support/shockwave/

GET SNAPPING!

Good original photography can add real impact and value to a website and with the advent of inexpensive film-processing, cheap photo scanners and vastly improved digital cameras, it's never been easier to get your snaps online.

DIGITAL CAMERAS

The two biggest drawbacks to digital photography are the expense of the cameras and the limited exposure control – falling into the 'point and shoot' category or having their advanced controls buried under an unwieldy interface. Most of the more expensive digital cameras do offer varying levels of control over exposure and it's really worth fiddling about with them – you'll learn more about photography by experimenting with different settings than letting some all-whirring wonder camera work it all out for you. Some also let you make short MPEG movies which are ideal for web use, but don't get too excited by cameras offering 'digital zoom' as it's rubbish. You can achieve exactly the same effect in any decent photo package (Paint Shop Pro, Photoshop etc.) by just cropping into the image detail you want and interpolating (resampling) it back up to the size you require to start with.

35MM CAMERAS

Don't throw out your old camera! Some of the greatest photographs were taken on simple range-finder cameras that had none of the clever electronic stuff seen on today's cameras – proving it's not the equipment that matters, but the talents of the photographer. You can get great results by scanning in prints from film cameras, and for the greater part, old cameras can perform just as well as their modern counterparts.

↗ **BEGINNER'S GUIDE TO PHOTOGRAPHIC EXPOSURE:**
www.cs.umbc.edu/~zwa/Photography/

↗ **DIGITAL CAMERA COMPARISONS:**
www.dpreview.com

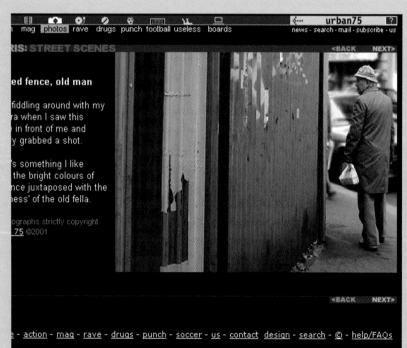

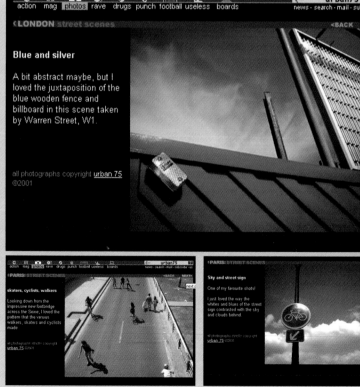

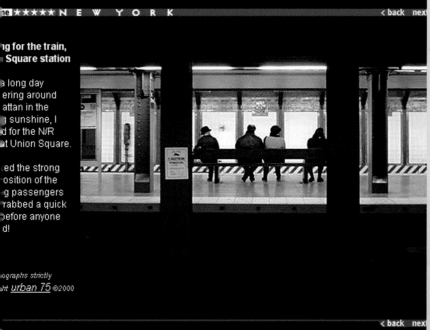

★★★★★ N E W Y O R K < back next

...g for the train,
...Square station

...a long day
...ering around
...attan in the
...sunshine, I
...d for the N/R
...t Union Square.

...ed the strong
...osition of the
...g passengers
...rabbed a quick
...efore anyone
...d!

...ographs strictly
...t *urban 75* ©2000

< back next

Why not dig out those photos and stick them on the web for others to enjoy or laugh at? Good photography can attract users and add originality to a site.

www.urban75.org/photos/

action mag photos rave drugs punch football useless boards news · search · mail · subscribe · us

‹LONDON street scenes ‹BACK NEXT›

Cranes, Canary Wharf

Looking like a race of mutant creatures, these huge cranes fill the skyline around Canary Wharf as the area around London's docklands continues to expand.

all photographs copyright **urban 75** ©2001

‹ london homepage ‹BACK NEXT›

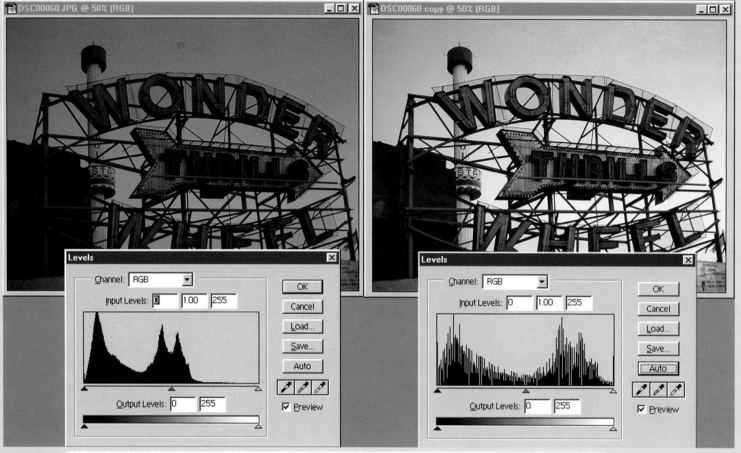

Photoshop has been used to liven up an image which is clearly too dark and
lacking detail.

Select Image -> Adjust -> Levels and you'll be presented with what looks like
a graphic of a precarious mountain range (called a 'Histogram'). This is a
representation of the amount of shadows, midtones and highlights in an image.
Moving the sliders around will increase and decrease these values.

In most cases, a simple bash on the 'auto button' is enough (as above), but if the
original picture is an underexposed snapshot of a bunch of black-clad coal miners
with dirty faces in a dark tunnel, don't expect miracles.

Histograms

SCANNING PRINTS

Always scan your images in at the highest resolution available and reduce down to 72dpi for web use later – you'll retain better quality by reducing the image rather than blowing it up. The higher resolution also gives you scope to crop and zoom into the image.

It's not unusual for scanned images or digital photographs to appear too dark or washed out onscreen, so expect to use your graphics editor. Remember to work on a copy of the scanned image in case you get a bit carried away in the filter department.

↗ SCANNING IMAGES FOR THE INTERNET:
www.scantips.com/
www.photo.net/philg/how-to-scan-photos.html

↗ TO ENSURE COLOUR CONSISTENCY YOU SHOULD CONSIDER CALIBRATING YOUR MONITOR:
www.devshed.com/Client_Side/Graphics/Scanning/page2.html

RESOURCES:

↗ BE INSPIRED BY THE WORK OF MASTERS!
Andre Kertész (**www.masters-of-photography.com/K/kertesz/kertesz.html**),
Henri Cartier-Bresson (**www.photology.com/bresson/**)
Bill Brandt (**www.billbrandt.com/**)

↗ PHOTO TERMS AND TECHNIQUES EXPLAINED:
www.dpreview.com/learn/glossary/

↗ TIPS ON PHOTOGRAPHY:
www.photoguides.com/PhotoTips/phototips.html
www.activepartners.com/amateurphoto/photo/techniques.html

AUDIO/VIDEO

First, let's get realistic: unless you've got a Titanic-sized wallet, you can forget about managing broadcast quality output on your home PC – the hardware and software may have got remarkably cheap in recent years, but it still costs a bomb to equip a PC for professional video work. You'd also need acres of hard-drive space as uncompressed, high-quality audio and video files chew up gigabytes for breakfast (a 640 x 480 pixel, 24 bit video clip at 30 frames per second chews up 27 megs a second – and that's without sound!).

But, all this doesn't matter for us internet types, because for the bandwidth-choked web, low-resolution clips are just fine. You'll still need a reasonably spec'ed machine equipped with a decent amount of RAM (128 megs upwards unless you like watching rotating hourglasses onscreen). If you're serious about producing multimedia content, get the best gear you can afford, as the old adage of garbage in, garbage out holds true. The higher the quality of your source file, the better. Always.

STREAMING

Media files come in two flavours: non-streaming – where the entire thing has to be downloaded before it can be heard, and streaming, which downloads bits at a time, playing as it downloads. Streaming is the only option for live broadcasts but listeners may have to install a plug-in. Non-streaming files are less complicated to set up and work better for small video clips and sounds.

Newer players can play a non-streaming file as if it was a streaming one, so you get the ease of creation and hosting without the wait, although such files use more bandwidth.

For the past few years, Apple, Microsoft and Real Networks have been slugging it out to grab the honours for streaming media and each has its advantages and disadvantages, but unfortunately they don't all support each other's formats.

This experimental site combines samples, music and imagery with Flash to create a suitably minimalist experience that perfectly complements Kraftwerk's music.

www.kraftwerk.com

VIDEO

To get video onto your machine, you'll either need a Digital Video camera with a FireWire/iLink port on your computer, a dedicated video capture card, or DAC (digital to analogue conversion) device. These convert the feed from digital to analogue for editing on the PC and let you output the finished results back to tape. Although top-end cards can be very pricey, budget models from Matrox (**www.matrox.com**) and ATi (**www.ati.com**) are fine for web work.

For making your movie you'll need a software video-editing package – unless by some miracle you manage to produce perfectly-edited files straight from camera. One of the best is Adobe Premiere (**www.adobe.com**) which has more than enough advanced features to produce Hollywood-threatening edits; but if the budget's tight, there's a host of shareware and cheaper alternatives, including the excellent Videowave video editor (**www.mgisoft.com**) and freeware VirtualDub (**www.virtualdub.org/**).

To get your masterpiece ready for the web, you'll need to encode it. Try to use the tools created by the manufacturer you want to use (Real, QuickTime, Windows Media) although for multiple formats, advanced filtering and batch editing, Terran Media Cleaner Pro's the one to go for

(**www.terran.com**). Don't forget you'll also need access to a server if you wish to stream the files – some ISPs offer RealMedia streams in their package, so shop around.

Video compression can be a painfully slow process, even on fast machines, so if you've a long clip, it might be time to brew up some tea. Remember to save often, as some machines can easily wheeze and fall over when working on such processor-heavy tasks.

FILMING FOR THE WEB

The more action happening onscreen, the bigger the file will be. If you're interviewing Mr Wobbly Head, insist on him keeping still. Don't record people wearing loud checked suits or bright red outfits as it'll look horrid onscreen. As ever, simplicity is the key: unless there's an overriding artistic reason, keep the camera on a tripod, leave out the creative spirit-of-1970 fast zooms and make the clips short and to the point.

👍 Always keep copies of all your footage in the highest quality format – when broadband arrives you'll want to have higher quality versions ready to roll.

AUTOBAHN

nopoly

playbay

logzone

hood

dragston

nopoly

playbay

logzone

hood

eboy.com's much imitated illustrative style has made their
site a well-established bookmark for inspiration-seeking
designers.

Serving up a rewarding mix of quirky, clever and downright
brilliant graphics, this design agency's site is definitely
worth a visit.

www.eboy.com

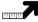

AUDIO

For producing and editing audio, there are loads of free and shareware audio editors on the web, although power users will benefit from fully-featured programs like Sound Forge, ProTools, CoolEdit and SoundEdit. You'll need a sound card on your machine and a microphone if you want to woo the world with your rap skills. Most cards have a 'line in' feature that lets you record from CDs, tapes etc., but be wary of breaching copyright.

Technologies like RealMedia can stream files so that users don't have to wait for the entire download before hearing anything. You don't have to have RealServer installed – you can stream the files to your visitors for free using a regular web server. Files can be output for streaming using the free RealProducer (➚ **www.real.com**). It's also worth checking out Microsoft's ASF format (➚ **www.microsoft.com/asf/**).

Always reduce audio sampling rates to as low as possible and consider if stereo is really necessary. Always warn people if a page has sound before they click on a link and give them the option to turn it off.

➚ **HTML TABLES:**
www.web-solve.com/html.tutorials/tables.htm
http://htmlgoodies.earthweb.com/tutors/table.html

➚ **RESOURCES:**

MULTIMEDIA AND THE WEB:
www.webreference.com/multimedia/audio.html
http://hotwired.lycos.com/webmonkey/multimedia/index.html

➚ **AUDIO:**
/www.streamingmediaworld.com/audio/tutor/master/
http://wdvl.com/Multimedia/Sound/Audio/
http://mmsound.about.com/compute/mmsound/

➚ **VIDEO:**
http://smw.internet.com/video/
www.dvmoviemaking.com
www.w3.org/Architecture/1998/06/Workshop/paper09/

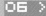

Producing a wide selection of rough home page designs is a great way to nail down the direction of the finished site. Try not to pick up my childish habit of putting in naughty words and silly comments as it can backfire in a big client presentation!

Design prototypes

PRESENTING PROTOTYPE DESIGNS TO CLIENTS

Presenting your ideas to a client can be a daunting process for some, so the more preparation you put in, the better. Rely on things going wrong, so copy your work onto your laptop, burn it onto a CD ROM and – as a last resort – post up a mini-site of the designs onto a test folder on your webspace.

Rather than having a load of sweaty execs smudging your expensive laptop screen, print out several copies of each design to give out. Websites don't float in a sea of white paper, so use a graphic editor to mock up a browser screengrab.

Many designers have different approaches to this stage of the process, but I prefer to knock out a set of quite different designs, ideally being able to present the client with six or seven possible 'looks'. There's a reason for this: if you go in with just the one design and the client hates it, you can only go on the defensive and – worst of all – give the opportunity for some non-designers to start chipping in with their (usually dire) 'suggestions'.

Go in with a choice of designs and you give the client loads of options, making them feel involved in the process (which always keeps their ego happy!). This maintains a positive meeting – even if they don't like any of the designs outright, odds on there'll be bits of them that will give you pointers for the final design.

Most importantly, listen to their responses carefully and make notes. When you return with the amended designs, be sure to point out all the changes made because of their suggestions, even if it's not remotely true.

Once you've got general agreement, get it in writing – then if the managing director later decides that purple is the new black, they can pay for it!

GET THE CODE RIGHT!

LINK CHECKERS

Some browsers are more forgiving of incorrect code than others, but just because something displays OK on your screen, it doesn't mean that others will see the same thing – check your site on as many browsers and other systems as possible.

Be as strict as you can with your code: writing correct syntax will increase the chance of a site doing well on a wide range of browsers and go some way to 'future-proofing' the site against new standards.

If you're working with a text editor it's especially important to validate your code for errors. Many editors come with built-in tools for checking your pages, but run your pages through a third party validator to make sure. Remember: just messing up one minuscule piece of code can result in the whole page going bananas!

One of my favourite utilities is HTMLValidator [PC] **www.htmlvalidator.com**, which integrates tightly with Homesite and reports on any syntax errors in your code,

offering handy tips on how to remedy the problem. Although it's not technically a fully-fledged validator, it's proved to be a real life-saver for many authors, particularly when trying to work out why a complex page isn't displaying properly. A more thorough validator can be downloaded from **www.arealvalidator.com** and you can test your pages online at **http://validator.w3.org/** and **www.htmlhelp.org/tools/validator/**

It's vital to have all the internal and external links within your site working, as nothing drives a surfer away quicker than a few '404 page not found' messages. For small sites, it's easy to check them online by simply clicking on every link you can find, but for larger sites, sophisticated commercial programs like Linkbot [PC] (**www.watchfire.com**) could prove a worthwhile investment. Xenu Link Sleuth **www.snafu.de/tilman/xenulink.htm** is a capable free alternative.

You can also run your pages through online link-checking services like **www.linkguard.com**, **www.netmechanic.com** and **www.siteowner.com/sitecheck.cfm**

UK DESIGN COMPANY DIGIT HAVE KNOCKED OUT MORE AWARD-WINNING SITES THAN MOST HUNGRY DESIGNERS HAVE HAD HOT DINNERS. DESIGN DIRECTOR NICK CRISTER SPEAKS ABOUT THEIR DESIGN PHILOSOPHY:

WHAT MAKES DIGIT UNIQUE?

We've always been passionate about doing something different with interactive media. Building a website has never been the objective, but surprising ourselves with something that we could never have imagined when starting is a real and productive challenge, even if that involves dredging through scrap-yards for inspiration!

HOW DO YOU APPROACH DESIGNING A SITE FOR A CLIENT?

The starting point is almost always to talk them very openly about their understanding of the medium, their requirements, restrictions and so on. Only when we have a very clear picture of their brand, audience, ambitions and ultimately resources will we begin to conceptualise a solution.

We usually start with four or five alternative designs (sometimes just sketches and ideas, other times working Flash movies, Photoshop and Freehand files – whatever is needed to get the ideas across), each one fulfilling the creative brief in a slightly different way. It's important that we should guide the client through our creative process as opposed to the other way around.

WHAT MAKES A NIGHTMARE CLIENT?

One who thinks they are unique and groundbreaking but then run a mile when pushed even slightly to stray from the norm. Or one who thinks that being able to use the internet and read the books makes them an expert in interactive design.

WHAT'S YOUR OPINION ON DESIGN VS. DOWNLOAD TIME?

It's a matter of both context and content. If I am going to enjoy learning, watching, listening or playing then I am willing to wait... If I wait to see a pointless piece of visual confetti then I get pissed off.

MUCH OF THE NEW TECHNOLOGY COMPROMISES ACCESSIBILITY – IS THIS INEVITABLE OR ARE DESIGN COMPANIES NOT DOING ENOUGH?

If accessibility is your goal and you fail then you can only blame yourself as a designer. There are arguments for hiding extra bits of a site, engaging the users in an exploratory narrative, using gameplay or intrigue to entertain but again it's all about context. Online Banking can be confusing enough without a designer showing off their new DHTML dropdowns.

IS THE COMMERCIALISATION OF THE WEB UNAVOIDABLE?

Considering how little the big corporates understand the web, it's actually quite a democratising place. I'm a big fan of the use of parody sites, for example, as a political communications tool. The largest challenge is how to map out and present content over the internet so that users still have a clear freedom of choice. It is control of the search engines, corporate channels and community sites such as AOL where censorship and preferentialism are now taking place.

WHAT ARE SOME OF YOUR FAVOURITE SITES AND WHY?

www.lessrain.com/web/main/shock/lounge/index.htm
Funny, original, elegant and great use of music.

http://acg.media.mit.edu/
The original home for digital designers.

ANY TIPS TO DESIGNERS STARTING OUT ON THE WEB?

I think the most important thing is to understand what makes the web different to other design disciplines and then to hone your skills by creating something unique and worthwhile.

IS THERE ANY ONE PIECE OF TECHNOLOGY THAT PARTICULARLY HELPS YOU?

Pen, paper, and an inquisitive mind – the rest you can learn.

07

MARKETING AND PROMOTING YOUR SITE

Simply putting a great-looking site up on the web isn't enough to generate traffic – you have to make sure it gets noticed, both online and offline.

The following chapter deals with the various techniques you can use to bump your site up the search-engine rankings, add interaction to your pages with bulletin boards, polls and chat rooms and provide enough of that 'sticky' content to keep your visitors coming back for more.

SEARCH ENGINES

O.K., you've finished your well-researched and in-depth website all about 'Beer-Drinking Competitions'. It's looking great, the content's spot on, and you're confident that anyone typing related words into a search engine will surely find you right at the top of the list. Except you're not. In fact you're nowhere to be seen, buried at the bottom of the pile thanks to search engines being saturated with similar-themed sites.

This isn't just bad news – it's disastrous! Research has shown that 80 percent of net surfers won't go beyond the top 30 of a search, so if you want your site to be found you're going to have to do battle with the complexities of search engines. These are really hard to figure out, as each one has a different way of indexing and ranking sites. Some like 'ALT' tags, others don't. Some will embrace your META Tag information like a long-lost brother while others will laugh in the face of your carefully compiled keywords and descriptions. Some will race through your immaculately constructed framed site, indexing wildly, while some won't even sniff past the front door. In some cases you may even wish to prevent this happening and will have to include yet more META Tags to tell those pesky indexing robots what not to index. It's not easy!

Part of the problem is that many of the search engines keep changing their criteria to stay ahead of ever-enthusiastic spammers trying to track and fiddle their way to the top. What may have been a top tip one minute rapidly becomes the quickest way to get your site ignored forever, the next.

For a while, ramming in the same keywords hundreds of times in the META Tags or sneakily filling up your home page with keywords the same colour as the background was the way to rise to the top of the pile – until the search engines got wise to that scam. These days you're automatically penalised for such tricks.

So how do you work your way through this minefield? Well, there's no off-the-peg solution, but a combination of persistence and judgement and a bit of knowledge about how search engines work can go a long way.

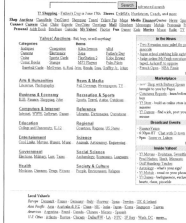

HOW SEARCH ENGINES WORK

Not all web-indexing systems are the same: *search engines* are huge databases of submitted websites that rely heavily on automated systems to both catalogue and rank web pages; *directories* use real people (gasp!) to catalogue and arrange submitted websites into their databases and *hybrid search engines* are search engines with an associated directory, either outsourced (usually from the dmoz Open Directory Project) or maintained by employees or consultants of that company. The latter type is nearly always overworked and near impossible to get listed on within a few months.

Search engines use a software 'spider' or 'crawler', this little fella spends its time roaming cyberspace reading every site it finds, and then following links to other pages within the site. Everything the spider finds goes into the search engine's index, although this can sometimes take several weeks. Spiders regularly return to sites – usually every month or two – to look for changes, sending the information back to the search engine index. For this reason it's important to keep your META information up to date to reflect any changes on your site.

The really clever stuff is done by the search-engine software. This sifts through the millions of pages recorded in the index to find matches to a search and then ranks them in order of what it believes to be the most relevant. This is calculated by its own unique criteria which can involve page titles, domain names, keywords, descriptions, page text, and link popularity or the colour of the MD's underpants.

It's in your interest to make your site as search-engine-friendly as possible. The following section highlights some of the more obvious ways to do this but because of space restrictions I'm only skimming the surface. Search engines are constantly changing their methods, so I strongly recommend checking out the sites listed in the 'resources' section at the end of the chapter.

META TAGS

META Tags can provide a useful way to influence how your summary might appear in search engines. They don't work in all of them, their mere inclusion won't guarantee a higher rating – but it might help. There are many META Tags, but the crucial ones are the 'description' and 'keywords' tags. The description tag returns a description of the page in place of the summary that a search engine would ordinarily create, and the keywords tag provides keywords for the search engine to associate with your page.

So if your website was about 'Getting Drunk' (and what could possibly be a better subject?), here's a short example of what your META Tags might look like:

<HEAD>
 <TITLE>Getting Drunk: beer drinking competitions**</TITLE>**
 <META name="description" content="Getting Drunk, the best web resource for beer drinking competitions featuring British beers and Belgian lagers**">**
 <META name="keywords" content="beer drinking competitions, getting drunk, British beer, Belgian lager, beer, lager, ale, drunkards, competitions, falling over**">**
</HEAD>

Note that you must separate the words with commas, or spaces. Resist the temptation to cram in thousands of keywords as search engines won't read them. Having more keywords also dilutes the effectiveness of your primary keywords (as search engines consider a site with very few keywords on a specific subject to be more relevant to that subject). Repeat the same words too many times and you might even be branded a steeenkin' spammer and have your site ignored completely, or worse, get blacklisted.

STRATEGIC KEYWORDS

It's important to pick the strategic keywords for your site carefully. Consider how people might search for your page. What words would they use? If your site is about 'Beer-Drinking Competitions', these are your strategic keywords, and if someone types that phrase into a search engine, you'd want to be right at the top of the list.

Different pages of the site should use different strategic keywords to reflect its content, so if a page was dedicated to 'Belgian lager', those would be its keywords. Vary your META and TITLE information from page to page for maximum effectiveness. If your site is geographically specific, include locale details. Generally search engines that index (and therefore list pages from deep inside your site) *do not* pay attention to your META Tags, so it's best to limit this kind of effort to major sections of the site rather than every individual page. You can then (if the search engine will allow it) submit these separate sections individually.

Your strategic keywords should be at least two or more words long and be positioned in crucial locations throughout the site; make sure you get them in your page title, page headline, META Tags and body copy. If the text is in an HTML table, it should ideally be placed in the top left-hand column – the trick is to get your keywords as 'high up' the page as possible to make them visibly relevant to the indexing robot. The higher the priority these words take in your code, the more relevant your page will seem to the robot.

It's also a good idea to include commonly misspelt or international variations and alternative meanings of your keywords (e.g. colour, color, tube, subway).

Using a set of minimalistic, quirky, animated icons for navigation, this comprehensive site serves up a diverse offering of original graphics, Flash animation, comics, interviews, music reviews and more. It's easy to get lost on the site, but there's more than enough interesting content to make the effort worthwhile.

www.audiodregs.com

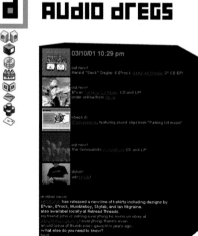

RELEVANT CONTENT

Of course, it would be easy to fill your page titles and meta tags full of enticing traffic-driving words like 'sex, more sex!', 'Free money!', 'MP3s', but if the site's content doesn't match this alluring offering, you may well get blacklisted by search engines. More to the point, those who do make it to your page will be less than impressed by your efforts to trick them and search engines will drop it like a stone.

Your keywords need to be reflected in the page's content, ideally in straight HTML text (search engines won't be able to make much sense of graphics-heavy pages, although some will index ALT text and comment information). It's a good idea to reinforce your keywords by referring to them in full throughout a page – so on your Belgium lager page don't refer to 'drunk people' but to 'people drunk on Belgian lager'.

Always include HTML hyperlinks from the home page to all the major sections of your website for search engine robots – and humans – to follow easily. It's also a good idea to include a site map page with text links to everything in your website and submit this to the search engines that like to spider to make sure that all of your pages are indexed.

FRAMES AND SEARCH ENGINES

Quite simply, you should avoid frames at all costs unless you absolutely have to. Unless you write a separate frameset for every page, people won't be able to bookmark individual pages and – worst of all – other sites or search engines may link directly to just your content frames, leaving visitors stranded without a navigation frame in sight.

In fact, search engines and frames really don't get on. Most search engine spiders don't understand the instructions on how to produce a frame layout, and will ignore everything except the information contained within the **<NOFRAMES>** tags.

If you want your framed site to have any hope of being indexed you should put in a detailed text description of the site within the **<NOFRAMES>** tag, and add a link to a text page listing the site's contents. This will provide a way for search engines and those on non-framed browsers to access the site.

To stop search engines linking to individual frames within a site you need to include a 'robots.txt' file in your home directory. This file contains a list of directories that should not be indexed by visiting spiders (though you must also consider that hackers often like to read these to see which folders in your site they shouldn't be poking around in). All pages other than framesets should be in separate directories, and those directories included in your 'robots.txt' file
http://wdvl.com/Location/Search/Robots.html or referenced using the **<meta name="robots" content="noindex,nofollow">** tag
www.lycos.com/help/robots.html

If users are being directed to pages without the surrounding frameset, an easy way to get them back is to add a

home page

link on the bottom of every page. Clicking on this link will bring back the surrounding frameset.

adr cartoons require FLASH
creatd by mumbleboy, e*rock, e*vax

E*VAX
parking lot music CD / LP
adr 37

track listing

01 the process of leaving <realaudio>
02 what we meant
03 contra costa
04 neon & aluminium
05 when i say go
06 tide pool
07 rinse <realaudio>
08 a-carter
09 we believe in broken bones
10 to make a fish
11 lemondale

photography by evan mast, mastered by trent holland.
black vinyl limited to 500
manufactured by datia
© audio dregs 2000

The simple design and bare minimum of navigational choices keeps the focus firmly on illustrator Evan Hecox's superb portfolio.

www.evanhecox.com

INDEXING DYNAMIC SITES

Search engines aren't too keen on dynamically-generated sites, so make them more search-engine-friendly by setting up 'doorway' pages for the main sections of your site. These are specially optimised Web pages (also known as entry or bridge pages) designed specifically to rank highly on the unique ranking algorithms of each search engine. There's quite a science involved in creating them, with the risk of being branded a pesky spammer if you get it wrong.

👍 Help search engines by including a static, text-only site map.

RESOURCES:

↗ **META TAGS:**
www.webdeveloper.com/categories/html/html_metatags.html

↗ **AUTOMATIC META TAG BUILDER:**
Meta Builder http://vancouver-webpages.com/VWbot/mk-metas.htm

↗ **SEARCH ENGINE OPTIMISATION:**
http://hotwired.lycos.com/webmonkey/01/23/index1a.html

↗ **SEARCH ENGINES AND FRAMES:**
http://searchenginewatch.com/webmasters/frames.html
www.cre8pc.com/howtoframes.html

↗ **CREATING DOORWAY PAGES:**
www.searchengines.com/doorway_pages.htm
www.webdevelopersjournal.com/articles/search_engines.html

↗ **THE INVISIBLE WEB: WHERE SEARCH ENGINES FEAR TO GO...**
www.powerhomebiz.com/vol25/invisible.htm

REGISTERING WITH SEARCH ENGINES

There's no denying that this is an arduous business, so put aside several hours on a rainy Sunday to go through all the major search engines, submitting the key two or three pages of your site (don't go berserk and repeatedly submit every page you've ever written as search engines may think you're spamming and penalise you).

Although deadly dull, this is an essential process, and if you've correctly optimised your pages your chances of a higher ranking should be considerably enhanced. You can use automated submission websites and commercial programs to speed up this process, but for the big search engines you're better off doing it manually, just to be sure.

If you're tempted by websites promising registration with 'up to 400 search engines and directories for $50 a year', don't be! They usually submit the bare minimum of information – which is unlikely to help promote your site at all – and are often very coy when it comes to listing who these 400 search engines and directories are. In truth, most of the 'specialised directories' on offer are 'free for all' links pages that will be of little or no use to you. There are many free online services that will do a similar job, or help you to do it yourself, check out:

- **www.jimtools.com**
- **www.searchenginegarage.com**
- **www.submit-it.com**
- **www.addme.com**

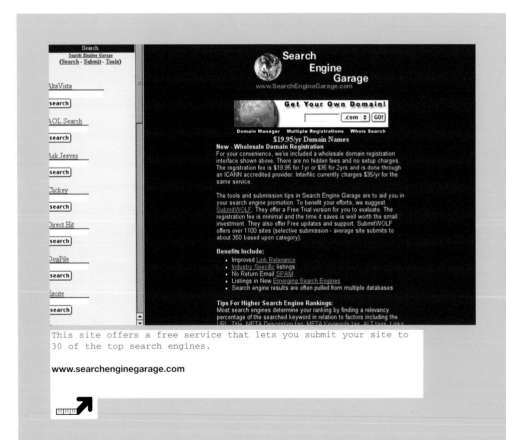

This site offers a free service that lets you submit your site to 30 of the top search engines.

www.searchenginegarage.com

URBAN75 RAVEDANCERS 3
urban75.com

vacuuming the apartment

music is on next ••••

URBAN75 RAVEDANCERS 4
urban75.com

punching the air...

music is on next ••••

URBAN75 RAVEDANCERS 5
urban75.com

explaining a dogfight

music is on next ••••

URBAN75 RAVEDANCERS 6
urban75.com

sorting out the sock drawer

music is on next ••••

URBAN75 RAV
urban75.com

vacuuming

music is on

Sometimes very simple ideas can generate huge amounts of traffic. These pop-up Flash rave dancers have ended up being linked to from hundreds of sites.
.
www.urban75.com/dance/

REGISTERING WITH DIRECTORIES

Directories work by carefully organising websites into subjects and categories, so take time to find the most appropriate category for your site – probably the one that contains entries similar to your own. Submit the page which you think is most relevant (not always your home page) and be sure to check out what information each directory needs before starting your registration (e.g. Yahoo requires a title, URL, description, category, contact information and final comment).

It may take many, many weeks to get listed, if at all – Yahoo accepts less than 20 percent of the sites submitted. Whatever you do, don't start bombarding them with repeat submissions. Here's what a UK Yahoo editor has to say, "The best way to proceed is to submit the site once to the relevant category. If you haven't heard anything within two weeks, submit again. If after another 2–3 weeks you still haven't heard back from us then submit a third time. If you follow this process but are still waiting for a reply from us, then you can contact the directory support team **ukurlsupport@uk.yahoo-inc.com** who will be happy to help you."

PAID LISTINGS

Sadly, it's now possible for fat cat companies to buy their way into the top of some search engines or pay for fast-track registrations. As the web gets ever more commercial, expect more of these kinds of deals to emerge. There are question marks as to how users will react to them – after all, when you search for something, it's the best match you're after, not who's paid the most. More about this at:

http://searchenginewatch.com/webmasters/paid.html

CHECKING YOUR LISTING

Search engines let you check to see if you've been successfully listed, but as they all use different techniques, there's not enough space to list them all. Search Engine Watch provides updated information for checking your listing at:

http://searchenginewatch.com/webmasters/checkurl.html

You can also use free or commercial 'position checking' services that check how your site ranks for different search terms on a number of search engines:

www.webpositiongold.com
www.topdog2000.com
www.positionagent.com

```
Photographer Mark Tucker had to teach himself HTML so he
wouldn't have to depend on others every time he wanted to
change a photo.

By using a simple interface, the beautiful photography does
all the talking.
```

www.marktucker.com

PERSONAL NASHVILLE BONGO PENROD PLUNGERCAM SNAKES ADVERTISING MUSIC MLKING STOCK CONT

penrod
A trip to my grandparents' homeplace

UPDATING YOUR LISTING

So, you've fine-tuned your pages, worked out your keywords and submitted the pages to as many search engines as you could find, but the work doesn't stop there; if you don't check and maintain your listings, you may slip to the bottom of the pile. If you find a competitor suddenly leaping above you in the rankings, examine their page and see what's giving them the edge. Search engines aren't infallible: they sometimes screw up, lose pages or produce out-of-date links, so it's worth keeping an eye on your listings and resubmitting if necessary. Do the same whenever you make significant changes to your site or if your URL changes.

CONCLUSION

Although there's a mass of clever tricks and cunning ploys to get your site ranked higher, that most important thing remains the same: the actual website itself. Produce the best on any given subject and you'll already have a headstart on the scammers and spammers trying to con their way to the top.

Although search engines remain the primary way people find stuff on the web, they're not the only way, and there's many other effective ways of driving traffic to your site, including word-of-mouth, traditional print and advertising media, newsgroup postings, web directories and links from other sites. Make sure you use them all if you want to keep attracting the right kind of traffic.

↗ SEARCH ENGINES RESOURCES
http://searchenginewatch.internet.com/
http://calafia.com/webmasters/
www.searchengineguide.com

Mark Tucker

PERSONAL NASHVILLE BONGO PENROD PLUNGERCAM SNAKES ADVERTISING MUSIC MLKING STOCK CONTAC

BONGO JAVA SHOW

These images came from a series of portraits that I did at a local coffeehouse. I shot each person on an 8x10 camera, made the print and gave it back to them for them to personalize.

PERSONAL NASHVILLE BONGO PENROD PLUNGERCAM SNAKES ADVERTISING MUSIC MLKING STOCK CONTACT ABOUT

Seagulls, Norwalk Connecticut

Photograph © 2001 Mark Tucker. This image cannot be downloaded without written permission. All entries to this site are recorded and logged.

[return]

CREATING 'STICKY' CONTENT

A sticky site is one where users can find fresh, regularly-updated content with all the background information, resources and tools relevant to the subject matter available within the site (that doesn't mean you shouldn't include any external links though – a carefully selected listing of useful sites can add real value). Try to anticipate a user's needs: if you're using technical jargon, link to a glossary; and if calculating tools are needed – such as a currency conversion tool – provide one.

The more depth-of-content a site provides, the more 'sticky' it will become, so it's worth keeping old content accessible through a search engine and adding links from current stories to relevant archives. Be sure to clearly mark these pages as archived and update their links to point to the newer material. Keep on the lookout for good resources: if you see interesting content on a lesser-known site, ask if you can reproduce it on your pages (with a credit and link back to the author, of course).

Constantly invite users for their opinions on stories and put in links to user comments at the end of articles. Pepper the sites with calls to action – 'feedback', 'what's your opinion?', 'do you agree?' – and make it easy for them to mail you by using a HTML form (see form tutorials at
↗ **http://htmlgoodies.earthweb.com/tutors/forms.html** and
↗ **http://wdvl.com/Authoring/HTML/Forms/**).

Once again, archive all of this material – it may well end up being rarely visited, but it will add credibility and depth to your site, and increase its chances of turning up in a wide variety of search engine queries.

Remember that content is the single most precious thing on your site, and so long as you keep it relevant, consistent, updated and accessible, you really can't get enough of the stuff.

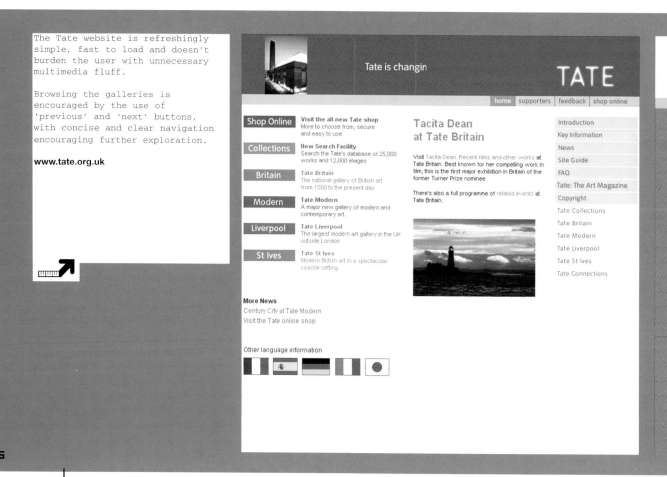

The Tate website is refreshingly simple, fast to load and doesn't burden the user with unnecessary multimedia fluff.

Browsing the galleries is encouraged by the use of 'previous' and 'next' buttons, with concise and clear navigation encouraging further exploration.

www.tate.org.uk

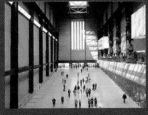

Tate Modern is now open

MODERN
TATE

home | supporters | feedback | shop online

Tate Modern

Tate Modern is Britain's new national museum of modern art.

Tate Collections
Tate Britain
Tate Modern
 Visiting Information
 Collection Displays
 Special Exhibitions
 Public Programmes
 The Building
Tate Liverpool
Tate St Ives
Tate Connections

Click here for a 3D Panorama of
the Turbine Hall (Java required).

Housed in the former Bankside Power Station, Tate Modern
displays the Tate collection of international modern art from
1900 to the present day, including major works by Dalí,
Picasso, Matisse, Rothko and Warhol as well as
contemporary work by artists such as Dorothy Cross, Gilbert
& George and Susan Hiller.

There is also a full range of special exhibitions and a broad
public programme of events throughout the year. Click on the
menu for more information.

Bankside Power Station has been transformed
into Tate Modern by the Swiss architects Herzog
& de Meuron. The former Turbine Hall, running
the whole length of the vast building, now marks
a breathtaking entrance to the gallery. From here
visitors are swept up by escalator through two
floors featuring a café, shop and auditorium to
three levels of galleries. At the top of the building
is a new two storey glass roof which not only
provides natural light into the galleries on the top
floors, but also houses a stunning cafe offering

Click here for more images of the Tate Modern

BRITAIN
TATE

home | supporters | feedback | shop online

Tate Collections
Tate Britain
 Visiting Information
 Collection Displays
 Special Exhibitions
 Public Programmes
 Future Plans
Tate Modern
Tate Liverpool
Tate St Ives
Tate Connections

...ain is the national gallery of British art from
...e present day, the Tudors to the Turner
...te holds the greatest collection of British
... world, including works by Blake,
...le, Epstein, Gainsborough, Gilbert and
...Hatoum, Hirst, Hockney, Hodgkin,
... Moore, Rossetti, Sickert, Spencer, Stubbs
...er.

...ry is the world centre for the
...nding and enjoyment of British art, and
...omote interest in British art internationally.

...ain shows British art in a dynamic series of
... special displays and exhibitions. Historic
...dern works hang together in challenging
...tion, drawing out new meanings from
...and familiar images.

...itions and broad
...so see 20th
...dern.

...ramme of
...s until 2001 on

25,000 works and
thousands of images
to explore

TATE

home | supporters | feedback | shop online

A B C D E F G H I J K L M N O P Q R S T U V W Y Z

General Collection | Artists A-Z | Artists S | Thomas Struth

Thomas Struth born 1954

National Gallery I, London 1989 1989

Photograph on paper on perspex (Fya)
image 1340mm x 1520mm
on paper, print
signed
Purchased with assistance from the Friends of
the Tate Gallery 1994
P77661

On display at Tate Modern
Display Theme: Concourse
Room Name: Level 1 Concourse

Read the Display Caption

◄ Previous work Next work ►

Tate Collections
 General collection
 Oppé collection
 Search collections
 Subject Index
 Archive
 Library
 Print Rooms
 Picture Library
Tate Britain
Tate Modern
Tate Liverpool
Tate St Ives
Tate Connections

© Thomas Struth

compiled 07 March 2001

A B C D E F G H I J K

General Collection | Artists A-Z | Ar...

Thomas Struth born 1954

National Gallery I, London 1989 198...

Photograph on paper on perspex (F...
image 1340mm x 1520mm
on paper, print
signed
Purchased with assistance from the...
the Tate Gallery 1994
P77661

On display at Tate Modern
Display Theme: Concourse
Room Name: Level 1 Concourse

Read the Display Caption

◄ Previous work Next work ►

compiled 07 March 2001

PROMOTING YOUR SITE

VIRAL MARKETING

This is the practice of marketing a site by word of mouth: users tell their friends about a great site/product/game, they then go on and tell all their friends etc. One of the most famous examples is Hotmail, who gained 12 million new users just by adding a one line tag line at the bottom of every mail sent from a Hotmail account.

Many companies now release interactive games as a *viral marketing tool* (or *viral agent*), with users being able to challenge friends by email and compete for high scores. The games usually carry some kind of enticement for users to visit the company's main page, either by giving them the chance to enter a prize draw or check their ratings against other players.

Guerilla marketing refers to the use of unconventional, unorthodox tactics to promote websites. One increasingly popular scam is to anonymously release amusing or obscene parodies of a client's advertising campaign, safe in the knowledge that it'll spread like wildfire across the web and do a very nice job of raising brand awareness in the process.

AWARD SCHEMES

Although there are some awards to boast about, many are the work of indescribably awful sites with horrendously ugly graphics for the 'winners' to display on their home page. If you're 'lucky' enough to be nominated, politely decline: the award graphic will slow down your page and impress nobody.

You can, of course, create your own awards scheme, ideally with a unique theme. You'll need to create a set of transparent GIFs with the cut-and-paste code for the winners to display on their sites and to dedicate sufficient time to reviewing candidates on a regular basis.
See examples at
↗ **www.awardsites.com**
↗ **www.web100.com**
↗ **www.botw.com**

It is, however, definitely worth nominating your site for the bigger web awards run by web magazines and companies like Yahoo ↗**www.yahoo.com** – gaining recognition at this level often impresses clients, although some of the more prestigious schemes demand payment for entries.

COOL SITES

Popular web showcase sites like ↗**www.linkdup.com** and ↗ **www.coolhomepages.com** list sites of interest to the web design community: if you feel your work is appropriate and up to scratch, ask them to feature your site.

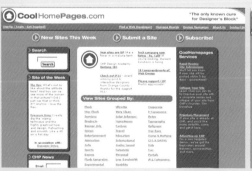

COMPETITIONS

A guaranteed way to drive traffic upwards is to offer weekly or monthly competitions, but you'll have to be prepared to promote it extensively – ideally offline as well as online – and offer a decent prize. Competitions are a good way to attract new content ('best short story/review etc.') or raise the profile of the site. Make sure you can deliver on the promised goodies and be prepared for people to try to cheat and fiddle their way in!

POSTCARDS

These let users send customised (and branded, naturally) electronic postcards from your site to their friends and colleagues. Some sites use complex Flash programming so users can 'build' their own personalised postcards, and the more successful ones are careful to make their offerings topical and seasonal, often with an amusing theme.

FREE CGI POSTCARD SCRIPTS FROM:
www.webmastercafe.com/scripts/postcard.html
www.icthus.net/CGI-City/scr_postcards2.shtml
Free hosted services at **http://mypostcards.com/**

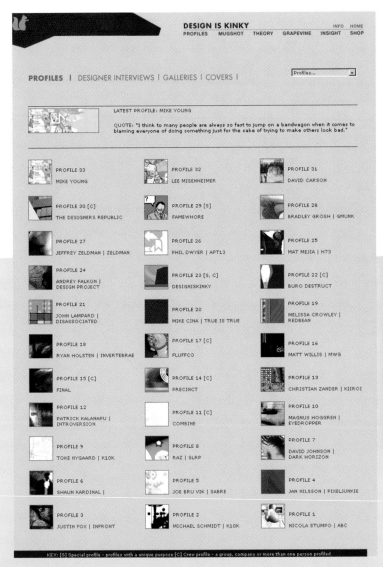

Getting featured in design 'zines like these can be a great way of letting the world know about your fab website.

www.designiskinky.net

MAILING LISTS

Regular email newsletters are a great way to keep visitors updated about new features and promotions on a site, but they should always be opt-in. To entice and reassure users, make it very clear what they might expect (typical content, how many newsletters per year, etc.) and never, ever sell on these addresses to anyone else. Free web-based tools like **www.coollist.com** make it easy to set up and administer mailing lists.

UNSOLICITED EMAIL (SPAM)

Spamming is the practice of sending out thousands – even millions – of adverts to strangers who have expressed no interest in your product or site. Cheap CDs containing untold amounts of email addresses can be readily bought on the net and may seem a great opportunity to promote your site on the cheap. Don't even think about it.

Spamming guarantees that your company and website will become wildly unpopular overnight, your ISP will terminate your account, you may well be mail-bombed (receive thousands of emails in one go) and even get phone calls in the middle of the night from the aforementioned strangers hurling abuse. Spamming is not big or clever and is never appropriate for promoting a legitimate site.

NEWSGROUPS (USENET)

Although newsgroups may appear a bit anarchic, many are bound by charters or FAQs, some of which specifically ban commercial adverts. Ignore these charters at your peril. One ill-advised advertising campaign on Usenet can seriously damage your company's credibility overnight, as can a drunken, late-night rant against your competitors. Usenet posts are archived for all to see so your nocturnal ramblings may come back to haunt you!

USENET GUIDE:
www.cnet.com/internet/0-3805-7-1564164.html

USENET ARCHIVES:
http://groups.google.com

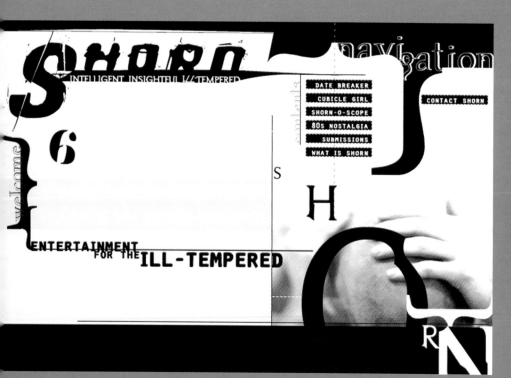

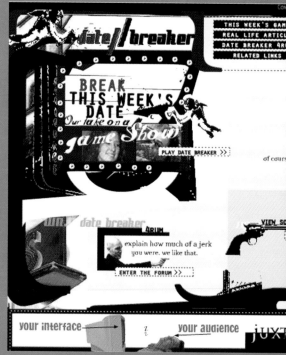

MAIL THIS PAGE

An effective way to promote your site's content is to provide a 'mail this page to a friend' button next to your content. There are commercial CGI scripts available:

 www.icthus.net/CGICity/scripts_mailthispage.shtml or you can use JavaScript to let users email the current page's address to a friend:

http://javascript.internet.com/page-details/email-this-page.html

BOOKMARK THIS PAGE NOW!

Make it easy for visitors using Internet Explorer to bookmark your page by adding this simple piece of JavaScript:

http://javascript.internet.com/page-details/book mark-us.html You can even let users set a page on your site as their home page using this script, (Internet Explorer 5+ only)

http://wsabstract.com/script/script2/home page.shtml

Authored in Flash, this site, advertising entertainment for the ill-tempered, combines humour and interaction with an original and quirky interface.

www.shorn.com

ADDING INTERACTION TO YOUR PAGES

With more and more websites offering freebie scripts and remote hosting, adding interactive elements to your site is a piece of cake. In most cases, all you'll need to do is register at the hosting service's site, and cut and paste some code into your page. Naturally, all of this generosity comes at a price, usually in the form of branded pop-up windows and horrid banner ads, removable for a small fee.

If you want more control over the look and functionality of the pages, you can download free CGI scripts from resources such as **www.freescripts.com**, **www.free-cgi.com/** and **http://cgi.resourceindex.com**

GUEST BOOKS/BULLETIN BOARDS/FORUMS

Giving visitors the opportunity to lavish praise on your site may not always get the desired effect, but it's a great way to encourage user feedback and generate content. Keep an eye on things though, as the web is full of mischievous pranksters who delight in disrupting such boards.

A busy bulletin board can add real value to a website and add a bit of life, but you have to work at it. If no-one's

posting, stir things up by manufacturing some outrageous quotes – even argue with yourself under a different name – and then post up snippets of the raging 'argument' on the front page, along with a link back to the boards. This should only be used as a last resort and unless you can make a convincing job of it, don't bother. If someone's posting up interesting and relevant content, flag it up and link to it from relevant articles within your site. If you've an interesting story breaking on your boards, make sure the press get to hear about it.

Some commercial web companies like to trot out the notion of 'community' and believe that slapping up a load of themed bulletin boards is somehow enough. It's not. Communities form around common interests, passions and issues in an environment where users can speak openly and freely. Unless a site has a credible association with the subject matter, it's unlikely to attract much traffic.

Businesses should always plan for the likely user demand of their boards – an empty board is not going to impress customers, neither will one completely overrun with customer complaints and abusive posts. Unless you can have the resources for real-time monitoring, moderate all posts (i.e. review before publishing).

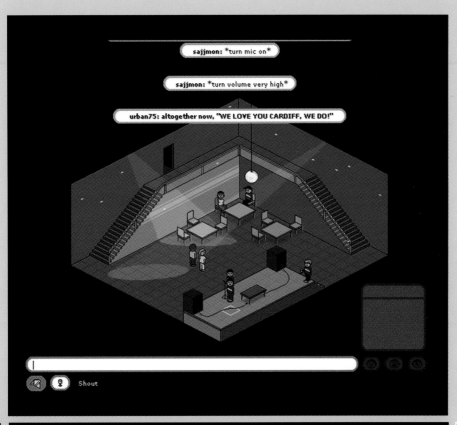

This hugely entertaining chat room uses Shockwave to let users wander around a virtual bar and disco and strike up conversations.

www.mobilesdisco.com

POLLS

These are a great way to add simple interaction to your site and bring life to a page. Ensure poll questions are updated regularly and make them topical, lively, amusing or ridiculous. Encourage more user interaction with a 'discuss this' button next to the poll results, linking to a dedicated thread on your bulletin board. Archive all results and comments, and if traffic's light, why not plant a few controversial quotes to motivate people?

CHATROOMS

Unless you're prepared to regularly spend time in your chat room, expect nothing but virtual tumbleweed to blow across your empty page. Even busy sites find it hard to keep their chat rooms stocked full of yapping folk, so consider posting up the times when you're going to be holding court – or if you can't be bothered, leave the chat function off your site altogether.

Try and persuade local celebs or dignitaries to agree to a live session and advertise it well in advance. Notify relevant press contacts and consider 'planting' a few controversial questioners on the day – with luck it'll make a good story and get reported in the press.

QUIZZES

Regularly updated quizzes can keep easily-amused people happy for hours, so it might pay to pepper a few through your site. If you're after a slick interface and maximum functionality, technologies like Flash and CGI are your best bet, but simple quizzes can be easily knocked out in JavaScript. Check out the example script at **http://javascript.internet.com/miscellaneous/user-quiz.html** or use the quiz generator at:
http://wsabstract.com/script/popquiz.htm

GAMES

A good game can send hit rates soaring and get everyone talking about your site. It's vital to ensure that the game is relevant to the content and theme of the site, otherwise users will just play the game and ignore the rest. For maximum publicity, quickly adapt games to reflect current news stories and promote them both offline and online.

It's not unusual for games to be 'borrowed' without permission, so make sure that all your work is branded (including your URL), carries a copyright mark and includes an embedded link back to your home page.

Online games can complement the theme of a site and can add real value and 'stickiness'.

www.urban75.com/Mag/brand.html

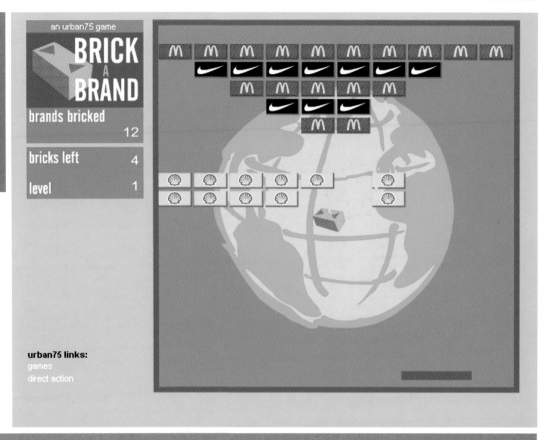

an urban75 game

BRICK A BRAND

brands bricked
12

bricks left
4

level
1

urban75 links:
games
direct action

Chat rooms can range from basic JavaScript to fully-featured Java and Flash versions. As often, simple is best. This impressive-looking, gizmo-laden Flash offering from Popwire only succeeded in crashing my browser.

http://city.popwire.com

FREE CONTENT!

Some companies will give you free newsfeeds for your site, but be warned – most will do little else than encourage users to get the full story from the home site. Always code the newsfeed into a separate HTML table to avoid potential delays. Check out: **www.isyndicate.com** and **www.moreover.com**.

RESOURCES

FREE BULLETIN BOARDS:
www.webstuff4free.com/freeforums.asp
www.forumco.com/
www.forumcities.com/
www.infopop.com

FREE POLLS:
www.alxpoll.com
www.freetools.com
www.pollit.com
www.mypoll.net

FREE CHAT ROOMS:
www.multicity.com
http://chat-forum.com/

FREE MAPS:
www.multimap.com
www.streetmap.co.uk

FREE WEB-BASED EMAIL:
www.gohip.com
www.bigmailbox.com

If you've a permanent web connection, a webcam can add a bit of fun to your site. You don't even have to worry about the view – some popular webcams point at extremely dull things! A searchable index of webcams can be found at: **www.camcentral.com/** and links to tutorial sites can be found at **www.webcamsearch.com/**
My favourite is 'New York taxi cam': **www.ny-taxi.com/**

Webcams

WRITING FOR THE WEB

Amazingly, many companies are happy delegating the responsibility for writing website content to all kinds of under-qualified people. I've known programmers, marketing execs, secretaries and all manner of sundry employees judged 'not bad at writing' being put forward as likely authors, usually with predictably indifferent results.

Writing for the web is not the same as writing a company report or short story, and if you can't find the appropriate skills in-house, considering hiring freelance web writers and editors.

HERE ARE SOME BASIC GUIDELINES:

KNOW YOUR READER

Make sure the tone and technical language is appropriate for the target audience. Stuffy corporate chest-beating rarely impresses those brought up on the more informal nature of the web – but that's no excuse to start filling up a financial site with mother-in-law jokes.

PLAN IT

Don't just bash out the first thing that comes into your head – work out the points you want to make in advance and organise the piece into a logical order with a defined conclusion.

This non-profit site is a homage to the late, great British comedian Peter Cook, and uses a vibrant mix of Flash and straight HTML to serve up a rich mix of content.

Peter Cook was one of Britain's greatest and most eccentric satirists and the site manages to reflect his quirky personality very effectively, with amusing Flash rollover animations and sound. Finding a good blend between functionality and fun, the site uses animated characters to guide users into different sections, with links to downloadable interviews, press articles and a comprehensive listing of the comedian's career.

Developed in his spare time by UK designer Ryan Brown, he describes **www.petercook.net** as, 'a personal project I've been working on off and on for about a year. I created it because there were no websites at all on one of Britain's funniest comedians.'

www.petercook.net

KEEP IT SHORT

Write half what you would for print. Keep it easy to scan by using small chunks of text with clear and concise headlines, sub-headings and bulleted lists. People dislike reading a lot of text onscreen (that's why the 'paperless office' never happened) so get to the point quickly and be succinct. Divide long stories up into manageable pages with a clear sub-navigation.

DON'T OVERWHELM THE READER

The golden rule is 'One subject or issue per paragraph and one idea per sentence'. Around 20 words is plenty for one sentence, fewer for those explaining complicated ideas.

USE SPELL-CHECKERS

Enlist as many people as you can to proof-read the content – spelling errors make any page look amateurish.

Although there are only a few pages on offer, Numero's simple, bilingual site is a useful tool for getting their Finnish skate-zine noticed.

http://numerozine.com/

EASE

Make it easy for users to know what's on offer: consider using the 'inverted pyramid' principle of journalism: start off with a conclusion, and then gradually add more detail.

KEEP IT READABLE

Small text is easier to read in sans-serif typefaces like Verdana. White text on a black background may look 'cool', but will rapidly become irritating for long articles. For maximum readability, use left-aligned dark text on a plain or light-coloured, non-textured background and AVOID THE USE OF CAPITALS.

CUT OUT THE JARGON

You may well know how to *align the DF366 T/S sprocket w/rear dipstick configuration* but others won't have a clue what you're on about. Avoid obscure technical jargon and abbreviations unless absolutely necessary – if they have to be used, include a glossary.

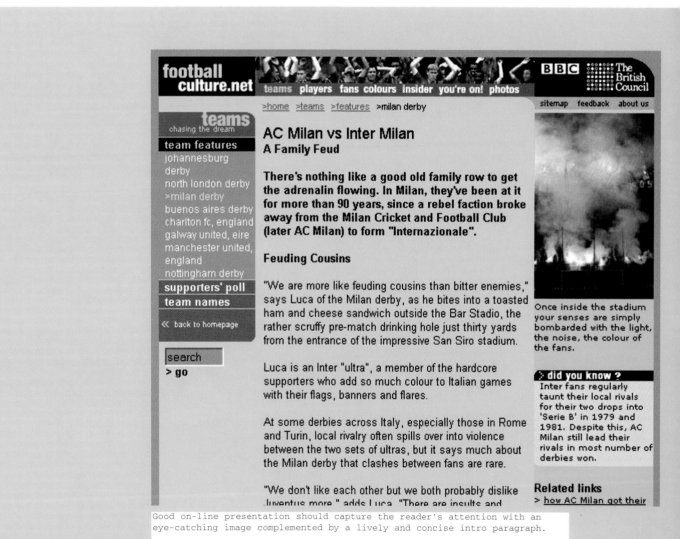

Good on-line presentation should capture the reader's attention with an eye-catching image complemented by a lively and concise intro paragraph.

Breaking long articles up into short paragraphs (with regular 'up' buttons' to save unnecessary scrolling) makes things easier for the reader, and when they get to the bottom of the article make sure there's either a 'next' button or links to related articles to keep them on the site.

www.footballculture.net

COPYRIGHT ISSUES

Although digital technologies make it easy to download images and multimedia clips, copyright laws apply to work published on the internet just the same as any other medium.

As a basic legal precaution, include the following on every page of your site, 'copyright © Your Name, 2002, ALL RIGHTS RESERVED' and link it to a full copyright statement.

If you find someone has stolen your work and is refusing to take it down, track down their details at sites like **http://combat.uxn.com/** and try writing to their ISP or to any banner ad companies linked to their site. In some cases, an ISP can be held liable for copyright infringement by its members. If that fails, it could be time to bluff wildly, and mail off a long legal-sounding letter and hope for the best – or be prepared to dig deep into your pocket for an internet lawyer.

Digital watermarking is seen as one way forward. Digimarc **www.digimarc.com**, offer a plug-in that works with most major image-editing packages. This applies an identifiable pattern of noise that cleverly embeds a copyright notice into your image. Viewers can then read this notice using the plug-in, and get in touch with the author using Digimarcs website. An annual charge is made for this service.

Of course, just because you're identifiable as the author, that won't stop Dodgy Webzine Weekly slapping your work all over their next issue. Copyright issues remain an extremely complex part of the law, and unless you have a team of hot shot lawyers constantly on call, there will always be a certain amount of a risk involved in putting your material on the web. Your best defence is to make your content as relevant and specific as possible to your business – and brand it as well.

RESOURCES:

COPYRIGHT WEBSITE:
www.benedict.com/

WORLD INTELLECTUAL PROPERTY ORGANISATION:
www.wipo.org/

COPYRIGHT LICENSING AGENCY:
www.cla.co.uk

TOP TEN COPYRIGHT MYTHS:
www.templetons.com/brad/copymyths.html

U.S. COPYRIGHT OFFICE:
www.loc.gov/copyright/

DIGITAL MILLENNIUM COPYRIGHT ACT:
www.loc.gov/copyright/reports/studies/dmca/dmca_study.html

PRIVACY POLICY

If your site collects sensitive or personal information, it's important to reassure users by providing a clear and comprehensive privacy policy explaining you're not going to flog off their information to the highest bidder. Write it so that it is clear and understandable, and provide a link for them to contact you for more information. You may also wish to use a short, personable message next to any part of your site that involves the use of their information and link this to your full privacy policy. Take a look at an example page: **www.excite.com/privacy_policy/** or read the privacy resources at: **www.truste.com/** and **www.w3.org/p3p/**

The object of SiSSYFiGHT 2000 is to ruin other players' popularity and self-esteem by physically attacking and dissing them until they are 'totally mortified beyond belief'.

www.sissyfight.com

LINKS! LINKS! LINKS!

Links are the lifeblood of any site, and with more and more search engines using link popularity as part of their ranking procedure, it's definitely in your interest to encourage people to link to your site.

RECIPROCAL LINKS

These are easy: link to sites similar to your own and drop them a polite line asking if they'd like to return the favour. In most cases, you'll be successful, but don't expect to be so lucky when linking to sites far busier than yours or ones owned by large companies. Bear in mind that other sites won't be impressed if they're only one of hundreds of links thrown together on an ugly page on your site: the more time and effort you put into making your links page relevant and coherent the more likely they are to take you seriously. You can check who's linking to your site in most of the major search engines by typing:

link:http://www.yoursite.com/index.html in the 'search' box.

WEB-RINGS/BANNER EXCHANGES

Usually of far more benefit to the instigator of the program, web-rings bundle together related sites, generally by means of a horrid interface that's almost guaranteed to consign your pages into the 'hopeful amateur' category. Banner exchanges are very similar, except you get thumping great banners on your page. With very few exceptions, you should ignore them and concentrate on getting listed in the major search engines instead. Banner exchange information can be found at **www.webmasterexchange.com**, **www.free-banners.com** and **www.123banners.com**

ADVERTISING NETWORKS

These offer a variety of means to earn revenue and promotion through pop-up windows, banners, 'click through' schemes and commission-based advertising.

Newer advertising techniques include 'interstitials' (ads that play between pages on a website) and 'superstitials' (ads combining Flash with Java programming to deliver video-like Web commercials).

Although the thought of all that filthy lucre just for sticking some ads on your page may be attractive, it's worth balancing it out with the detrimental effects on download speed, site appearance and, of course, the traffic rate: if someone sees a tempting advert for a better-looking site, they'll be gone!

WHO'S VISITING YOUR SITE?

Each time someone visits a site, the server records information about their activities on the site in a server log. These can then be analysed using specialised programs like webtrends (www.webtrends.com, or see the full software listing at www.counterguide.com/logs.html) or by using free online services like www.counted.com and www.thecounter.com

Server logs can tell you the date and time of visits, the browser and operating system used, how long the visitor stayed, where they came from, on what page they entered and left the site, what pages they looked at, their domain and county code and even the keywords they typed into a search engine to find your site.

This information can prove invaluable. If a lot of people are leaving your site on a specific page, try adding new content or links there. If people are accessing your site using browsers that don't support your features, consider building an alternative version for them.

Don't display counters on your home page. They look crap.

ADVANCED WEBSITE PROMOTION:
www.cral.ac.uk/guidelines/search/advanced_promo.html

HOW CAN I SELL THE BANNER AD SPACE ON MY WEBSITE:
www.adbility.com/helpsell.ht

This Canadian-based 'culture jamming' organisation publishes a no-ads print magazine, with many of the articles reproduced and archived on their colourful and informative website.

Dealing with issues such as the 'erosion of our physical and cultural environments by commercial forces', many of the stories carry a useful set of related links, making it easy for readers to delve deeper into corporate malpractices!

www.adbusters.org

PARTING SHOT

It would have been easy to fill this book with impressive, glossy, corporate websites but I've intentionally avoided doing so. Big budgets may well buy you a slick design but I'm always more interested in seeing sites put together for fun, for artistic pleasure or for the sheer hell of it rather than looking at another mega-buck spectacular trying to convince me of the 'brand values' of a pair of trainers.

I stumbled into web design after starting a campaign about football fans' rights back in 1995. Although the site was extremely basic, it proved a very effective way to get my message across at little cost and made it easy for fans to share their stories.

As my confidence and web skills increased, I started adding other elements to the site that interested me, and as it grew in size I found myself having to acquire new skills quickly – like learning how to organise and manage hundreds of pages!

Spurred on by encouraging comments from others, I added new sections that reflected my personal areas of interest, covering a diverse range of subjects from personal photography, rants about the commercialisation of the rave scene, no-nonsense drug information, direct action news and a growing collection of silly games.

The next thing I knew, the site was attracting thousands of visitors every day and I was being offered employment as a freelance designer, working all over the world!

To me, this is the real beauty of the web: anyone can have a go and it gives individuals the opportunity to freely share their ideas and opinions with people all over the planet.

I hope this book has succeeded in inspiring you to get your own website online, but be warned: if the HTML bug bites it can end up taking over your life!

Mike Slocombe

WWW.MAX-HITS.NET

Check out the companion website to the book.
This contains regularly updated links to more
great sites!

www.antidot.com

www.antidot.com

www.sissyfight.com

www.retroscope.com

www.radiohead

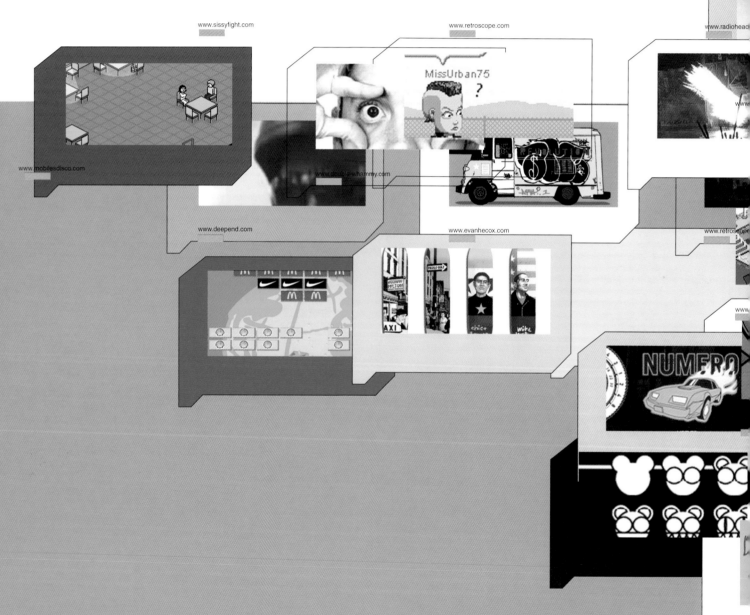

MissUrban75

www.mobilesdisco.com

www.double-whammy.com

www.deepend.com

www.evanhecox.com

www.retroscope

NUMERO

AXI

chico

mike

ARTISTICA *EXPERIMENTALS*

V2

Continued Visual Experiments

The Modern Era | Urban 8 | Monaco '63

www.artistica.org

TBL™
The Bearded Lady

www.kraftwerk.de

www.beardedlady.com

1960s

www.petercook.net

www.petercook.net

www.copyrightdavis.com

Smith's
MILK CHEWS

Luxury
FUDGE AU LAIT

MILK IN

www.scooterdeath.com

...death.com

www.presstube.com

You mig
I'm not
the pac
thing yc
I ended
★ updat

www.bongo11.com

www.presstube.com



FURTHER READING

WEB:

'Great Web Architecture', Clay Andres
IDG Books (ISBN 0–7645–3246–4)

'New Internet Project: Reloaded', Burgoyne/Faber
Calmann & King (ISBN 0–7893–0362–0)

'HTML for the WWW', Elizabeth Castro
Visual Quickstart series, Peachpit Press (ISBN 0–201–35493–4)

'Flash 5 Advanced', Russell Chun
Visual QuickPro Guide (ISBN 0–201–72624–6)

'Marketing Your Website', Tim Ireland
Net Works ISBN 1–873668–87–2

'JavaScript for the WWW', Negrino/Smith
Visual Quickstart series, Peachpit Press (ISBN 0–201–35463–2)

'Designing Web Usability', Jakob Nielsen
New Riders (ISBN 1–56205–810–X)

DESIGN:

'End of Print: Graphic Design of David Carson', Lewis Blackwell
Laurence King (ISBN 1–85660–070–9)

'Typographics Three', Roger Walton
Hearst Books (ISBN 0–688–16393–9)

'Graphics: Real World Graphic Design projects', Paul Murphy
RotoVision (ISBN 2–88046–330–0)

MAGAZINES:

Internet Magazine (UK)
Eye Magazine (UK)
Creative Review (UK)
Design Week (UK)
Create Online (UK)
Print Magazine (US)

ACKNOWLEDGEMENTS

Thanks to all those who put up with my endless bleating as I
battled my way through this book with extra special thanks to
Emerald Mosley for the words of encouragement. Lofty credits are
also due to Tim Ireland and Jim Ley for their advice and technical
help and to all those involved in producing and marketing the lump
of paper in your hand, including Tim Hutchinson and Jason
Edwards of Bark Design, Luke Mitchell, Natalia Price-Cabrera and
Kate Noël-Paton at RotoVision. Good work fellas!

A big shout goes out to Dave Wilby and the mob at Internet
Magazine, Andy Hansen, Richard Mellor, David Sharples, Bill
Wright, Gwynne Reddick, Matt Wilson, Fran Benincasa, Nick
Lyons, Kerri Sharp, Steve Marchant, Andy Foulds, the SchNEWS
crew, the Prince Albert pub in Brixton (for the much needed lager
breaks) and, strangely enough, the beastly UK Tory government –
if they hadn't announced the dreadful Criminal Justice Act back in
1995 I would never have started up a website to fight it!

Dedicated to Jonah George Williams, Steve Lockyer, Jake Lee, the
various-sized Slocombes scattered around Wales and, of course,
the mighty Cardiff City FC!